COLOR

First published in the United States of America by:
Rockport Publishers, Inc.
33 Commercial Street
Gloucester, Massachusetts 01930-5089
Telephone: (978) 282-9590
Facsimile: (978) 283-2742

Distributed to the book trade and art trade in the United States by:
North Light Books, an imprint of
F & W Publications
1507 Dana Avenue
Cincinnati, Ohio 45207
Telephone: (800) 289-0963

Other Distribution by:
Rockport Publishers, Inc.
Gloucester, Massachusetts 01930-5089

ISBN 1-56496-375-6
10 9 8 7 6 5 4 3 2 1
Selected and edited by Joyce Rutter Kaye
Designer: Monty Lewis

Printed in HongKong by Midas Printing Limited.

graphicidea

resource

Joyce Rutter Kaye

ROCKPORT
PUBLISHERS

Rockport Publishers, Inc.
Gloucester, Massachusetts
Distributed by North Light Books
Cincinnati, Ohio

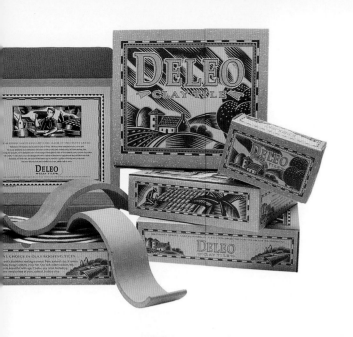

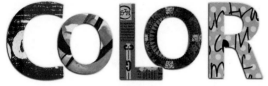

COLOR communicates instantly. Even before the text in a layout is read and the words are registered and processed, the color scheme has already conveyed something on another, subconscious, level. Color often has loaded political, social, and emotional connotations. During the Cold War, to be called "red" in America was to be branded the worst kind of traitor. Everyone knows that yellow has long been associated with cowards. And if you devote yourself to protecting the environment, you are known to be "green."

It takes a discriminating eye to determine what color or color scheme works best to create the biggest impact on an audience. It also takes an innovative mind to make the most of limited choices when budgetary concerns restrict the amount of color that can be used on press. On these pages are many examples of ways designers found to stretch their color options, such as changing paper colors instead of inks to broaden a color spectrum, or applying a third color by hand to a 2-color run.

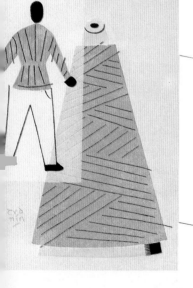

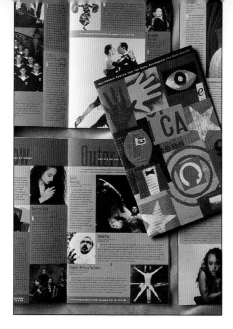

JOANNE C. L
Vice President & Crea
10300 Sunset Drive, Suite 353,
Telephone 305·271·2063 Fac

Trends in color reflect the cultural concerns of the day. Recently it has become popular to promote "green" or "natural" products in an earthy color scheme that reflects their natural resources. Packaging designed in brown, black, and beige tones printed on fibrous kraft paper remains a popular option for products sold in health food stores, or for graphics found in the now-ubiquitous upscale coffee bars.

Desktop publishing technology has facilitated the ability to achieve special effects by applying and layering color in a design. In fact, highly layered and saturated color has become synonymous with design in the early-to-mid 1990s, especially in CD-ROM interfaces and in Web site designs. Now the tendency is away from overindulgence and toward a more limited use of color within layouts that incorporate more white space. This restrained approach comes as a welcome relief as media forms proliferate the landscape and add to the sensory overload. When communicating with color, graphic designers are smart to realize that it's not always the one who shouts the loudest that gets the most attention.

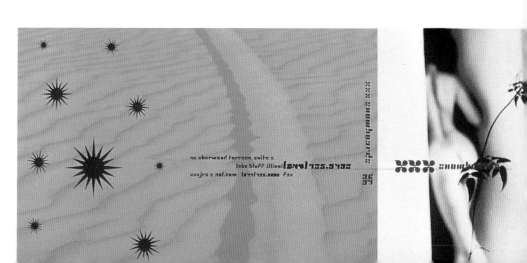

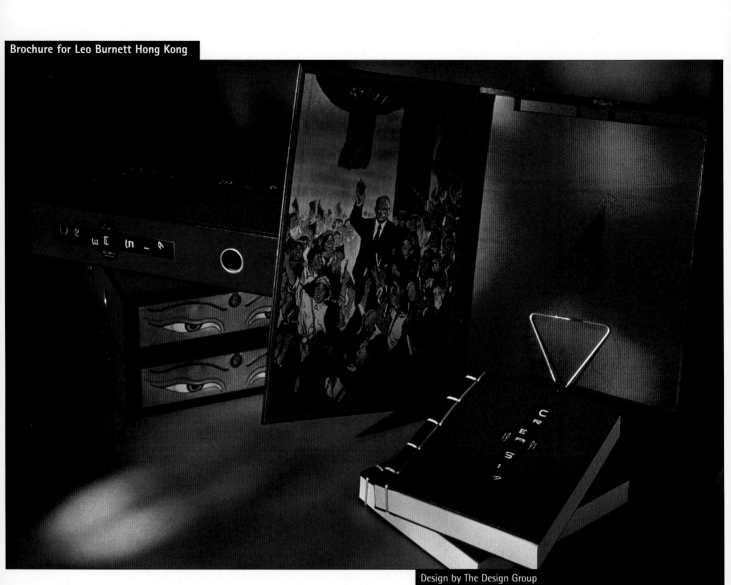

Design by The Design Group
Art Director/Copywriter: Stefan Sagmeister
Designers: Stefan Sagmeister, Peter Rae, Patrick Daily

This piece was created for an advertising conference in Hong Kong. The choice of red for the cover reflects the national color of Communist China; the notebook is styled to mimic the Red Book.

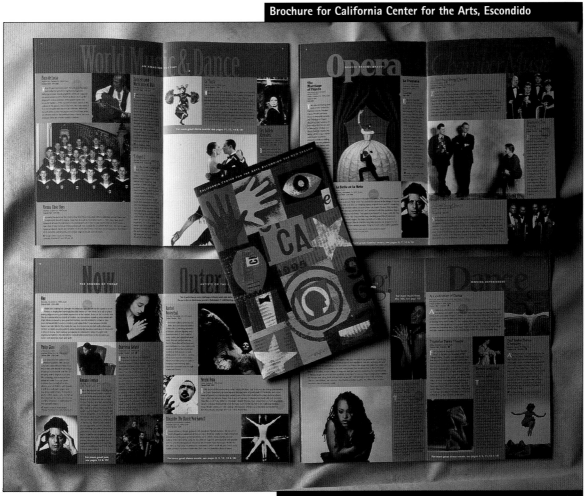

Design by Mires Design, Inc.
Art Director: John Ball
Designers: John Ball, Kathy Carpentier-Moore
Illustrator: Gerald Bustamante

This brochure promotes events at the California Center for the Arts with an upbeat color-block format with each hue identifying an art form. The colors are united as a patchwork on the booklet's cover.

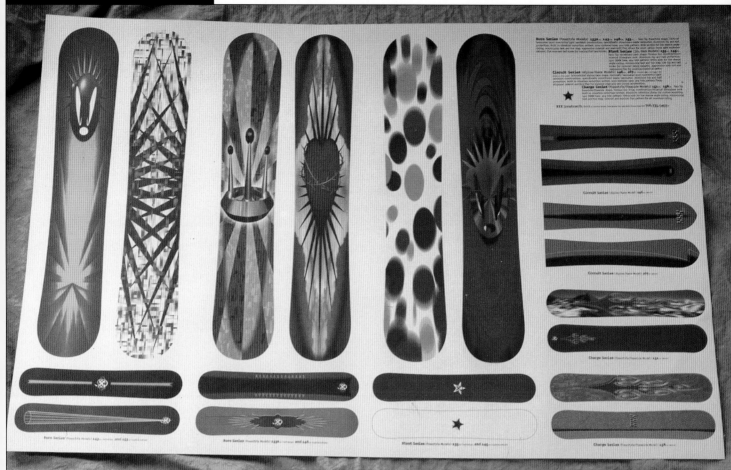

A brochure created for a snowboard manufacturer avoids the category's standard-issue garishness with a soft, sepia-toned image of a snowboarder on the cover and displays of the product on cream-colored paper.

Design by Segura, Inc.
Art Director/Designer: Carlos Segura
Illustrators: Tony Klassen, Carlos Segura
Photographer: Jeff Sciortino

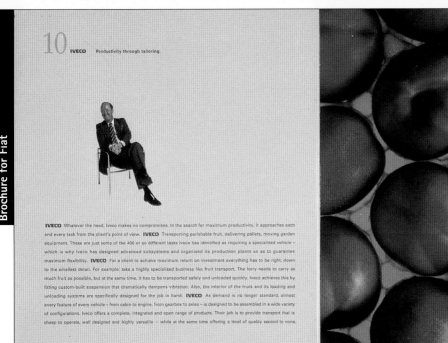

10 IVECO Productivity through tailoring.

IVECO Whatever the need, Iveco makes no compromises. In the search for maximum productivity, it approaches each and every task from the client's point of view. **IVECO** Transporting perishable fruit, delivering pallets, moving garden equipment. These are just some of the 400 or so different tasks Iveco has identified as requiring a specialised vehicle – which is why Iveco has designed advanced subsystems and organised its production plants so as to guarantee maximum flexibility. **IVECO** For a client to achieve maximum return on investment everything has to be right, down to the smallest detail. For example: take a highly specialised business like fruit transport. The lorry needs to carry as much fruit as possible, but at the same time, it has to be transported safely and unloaded quickly. Iveco achieves this by fitting custom-built suspension that dramatically dampens vibration. Also, the interior of the truck and its loading and unloading systems are specifically designed for the job in hand. **IVECO** As demand is no longer standard, almost every feature of every vehicle – from cabin to engine, from gearbox to axles – is designed to be assembled in a wide variety of configurations. Iveco offers a complete, integrated and open range of products. Their job is to provide transport that is cheap to operate, well designed and highly versatile – while at the same time offering a level of quality second to none.

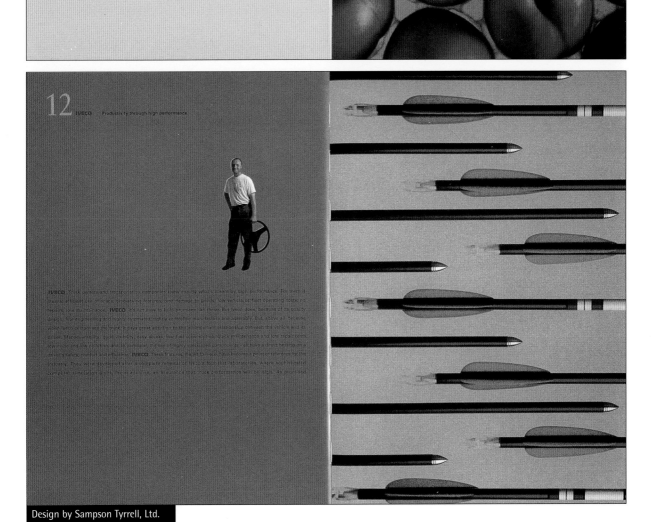

12 IVECO Productivity through high performance.

IVECO Truck owners and transportation companies know exactly what's meant by high performance. For them it means efficient gas mileage, time-saving features, zero damage to goods, low vehicle or fleet operating costs, no repairs, low maintenance. **IVECO** It's not easy to fulfil promises like these. But Iveco does, because of its quality design, fine engineering and highly automated, tightly controlled manufacture and assembly. But, above all, because when Iveco customises the truck, it pays great attention to the all-important relationship between the vehicle and its driver. Manoeuvrability, good visibility, easy access, low fuel consumption, quick maintenance and low repair costs, low noise and low pollution, and in particular, the use of highly specialised components – all have a direct bearing on a driver's safety, comfort and efficiency. **IVECO** These features driven by Iveco have become a point of reference for the industry. They were developed after a complete renewal of Iveco's four test laboratories, where sophisticated computer simulation gives, even in advance, an assurance that truck performance will be high. As promised.

Design by Sampson Tyrrell, Ltd.
Art Director: David Freeman
Designer: Shane Greaves

A division of Fiat that develops customized trucks for shipping is promoted in a booklet with spreads saturated with brilliant colors that appear as backgrounds to text pages and in close-up photographs of fragile goods.

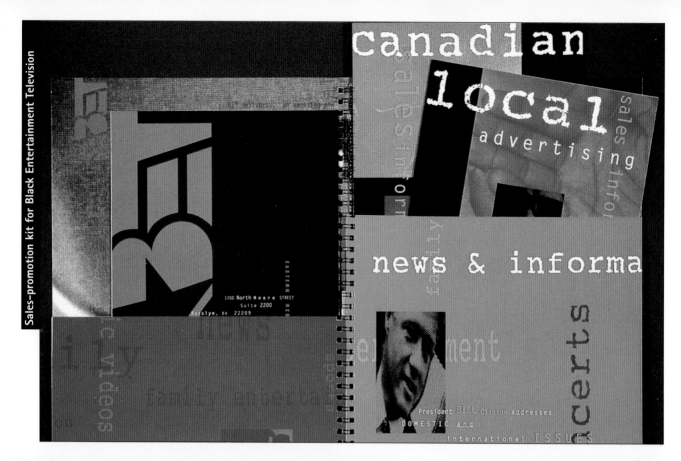

Sales-promotion kit for Black Entertainment Television

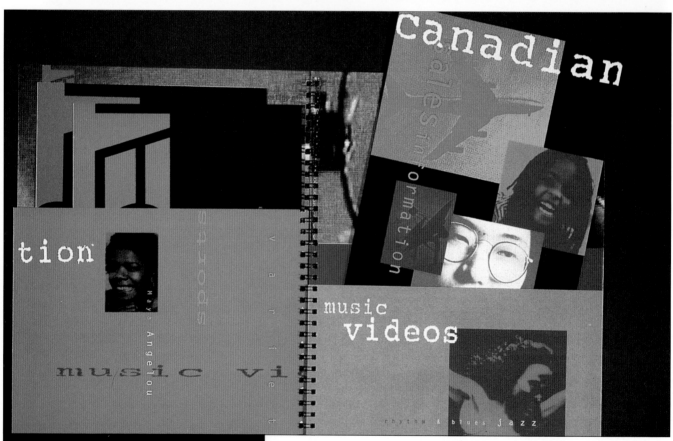

Design by Supon Design Group, Inc.
Art Directors: Supon Phornirunlit, Andrew Dolan
Creative Director: Scott Perkins
Designer: Andrew Berman
Project Directors: LaTanya Butler, Angela Scott, Matilda Ivey

A dynamic look for the Black Entertainment Television cable network is created through a sales-promotion kit designed in shades of green, blue, orange, and yellow. Type also appears in color for extra punch.

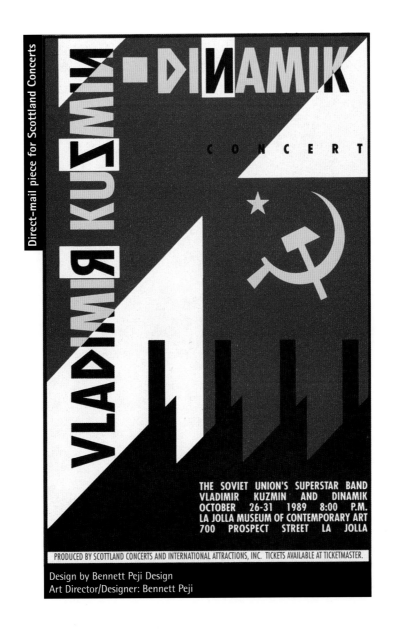

This poster for a performance of Russian musicians pays homage to the post-revolution Constructivist movement with bold geometric lines and a color palette synonymous with the former Communist state.

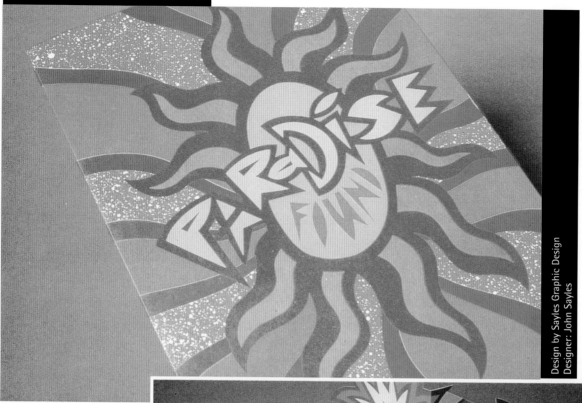

Design by Sayles Graphic Design
Designer: John Sayles

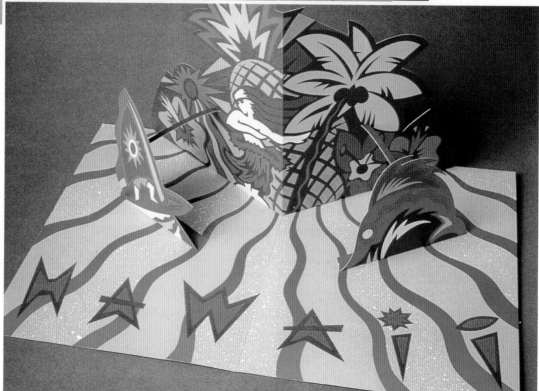

A tropical color scheme illustrating all things Hawaiian—surfing, hula dancing, palm trees, and pineapples—pops up in this promotional mailer for an Alexander Hamilton Life sales meeting. You can almost smell the tanning lotion.

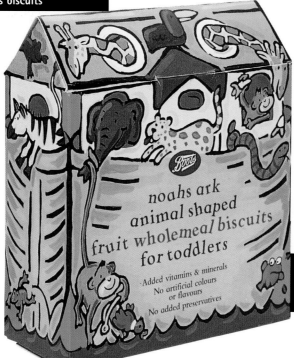

Design by Newell and Sorrell
Art Directors: Frances Newell, John Sorrell
Designer: Angela Porter
Illustrator: Tania Hart Newton

A broad palette of nursery colors adds to the whimsy of the Noah's ark illustration on this package of cookies for toddlers from Boots.

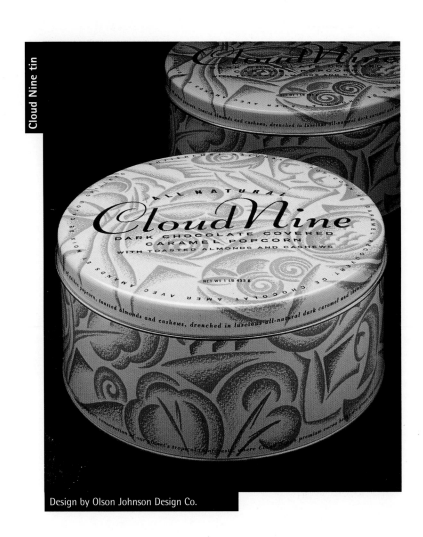

Design by Olson Johnson Design Co.

An illustration of a floral
design in soft tones of peach
and green on an ecru tin
creates an up-market,
ethereal package design for
Cloud Nine confections.

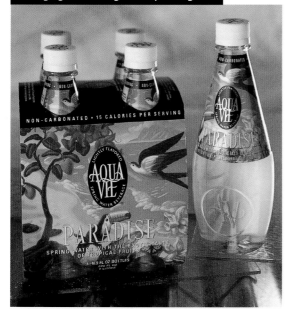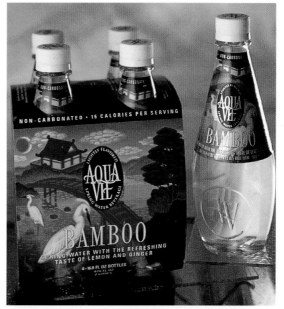

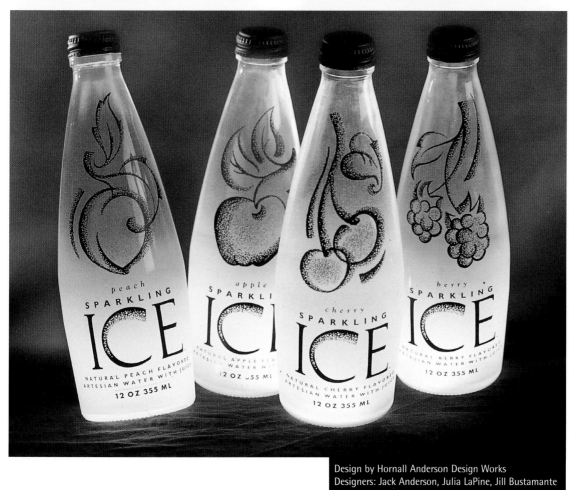

Design by Hornall Anderson Design Works
Designers: Jack Anderson, Julia LaPine, Jill Bustamante

Bottles tinted in cool tones and illustrated with frosty line drawings of fruit,

promise the pure refreshment offered by this sparkling beverage. The accents

in black provide contrast and add to its upscale image.

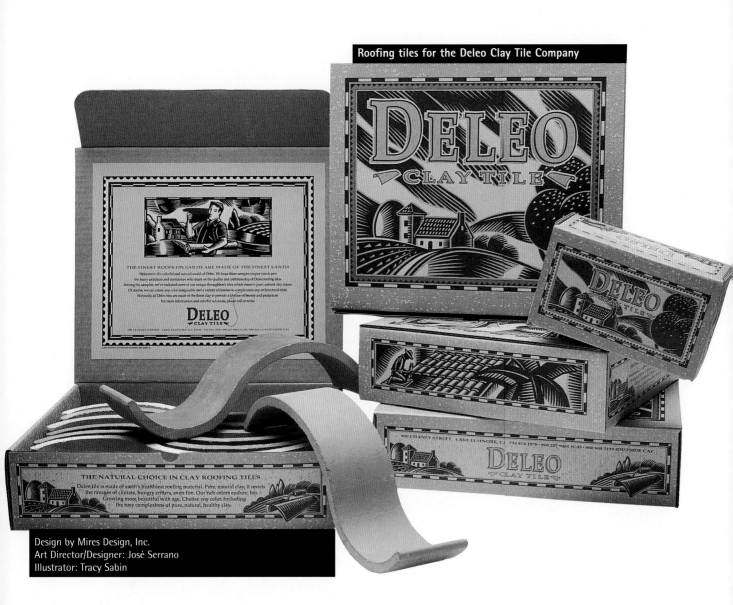

Roofing tiles for the Deleo Clay Tile Company

THE FINEST ROOFS ON EARTH ARE MADE OF THE FINEST EARTH

DELEO
CLAY TILE

THE NATURAL CHOICE IN CLAY ROOFING TILES

DELEO
CLAY TILE

Design by Mires Design, Inc.
Art Director/Designer: José Serrano
Illustrator: Tracy Sabin

The richness of the earth is conveyed in the color scheme of this packaging for Deleo clay tiles. The corrugated cardboard boxes with woodcut illustrations of farmland draw attention to the natural source of the materials and to the product's subtle russet colors.

The warmth and richness of the fine coffee-drinking experience is reflected in the warm hues of red, orange, and green on packaging for Starbucks and creates a foil for the bold green-and-white Starbucks logo.

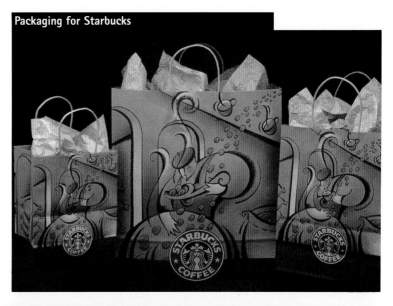

Packaging for Starbucks

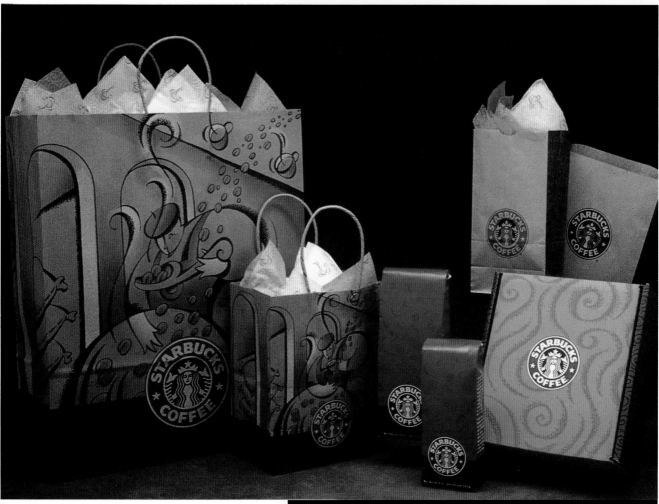

Design by Hornall Anderson Design Works
Designers: Jack Anderson, Julie Tanagi-Lock, Mary Hermes, David Bates, Julie Keenan
Illustrator: Julia LaPine
Photographer: Tom McMackin

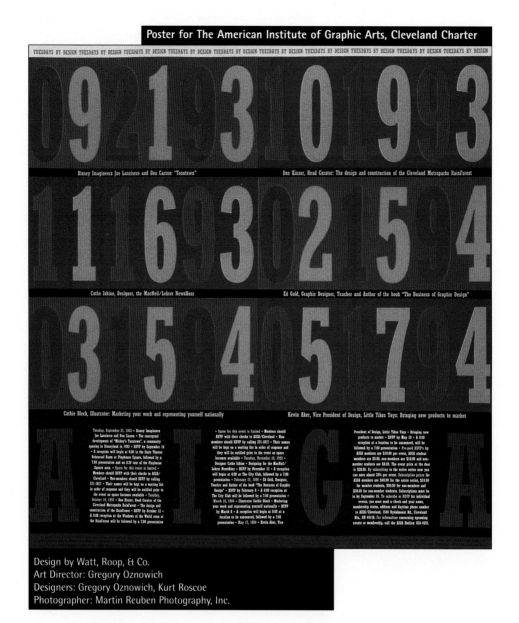

Poster for The American Institute of Graphic Arts, Cleveland Charter

Design by Watt, Roop, & Co.
Art Director: Gregory Oznowich
Designers: Gregory Oznowich, Kurt Roscoe
Photographer: Martin Reuben Photography, Inc.

Mark your calendars: bright, solid PMS colors highlight the prominent dates on this poster promoting the Tuesdays by Design speaker series hosted by the AIGA.

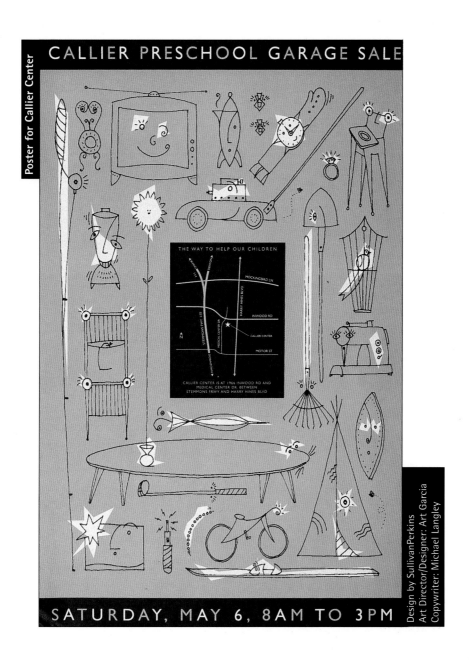

For this poster advertising a garage sale, a 1960s flavor was created through the use of an illustration style of that decade and the choice of a mustard color for the background.

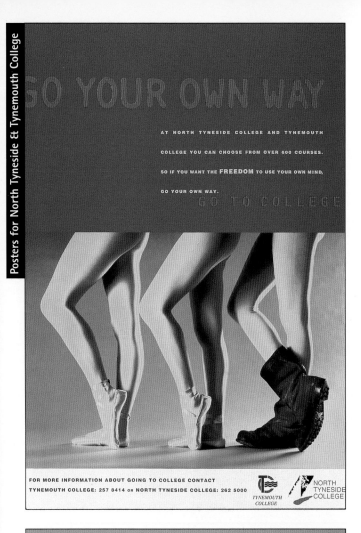

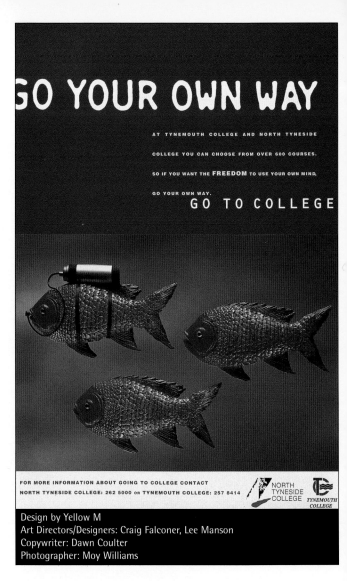

Design by Yellow M
Art Directors/Designers: Craig Falconer, Lee Manson
Copywriter: Dawn Coulter
Photographer: Moy Williams

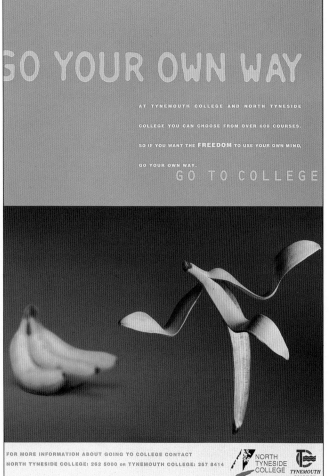

Individual style and freedom of choice is the focus of these posters, where visual punch lines are created within a format that divides the page into a top half in arresting shades of orange, red, blue, or aqua with contrasting type, and a bottom half with a visual joke.

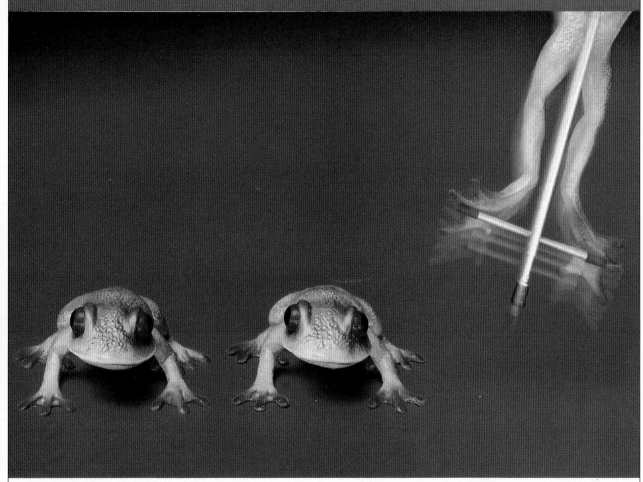

GO YOUR OWN WAY

AT NORTH TYNESIDE COLLEGE AND TYNEMOUTH

COLLEGE YOU CAN CHOOSE FROM OVER 600 COURSES.

SO IF YOU WANT THE **FREEDOM** TO USE YOUR OWN MIND,

GO YOUR OWN WAY.

GO TO COLLEGE

FOR MORE INFORMATION ABOUT GOING TO COLLEGE CONTACT
TYNEMOUTH COLLEGE: 257 8414 OR **NORTH TYNESIDE COLLEGE: 262 5000**

TYNEMOUTH COLLEGE

NORTH
TYNESIDE
COLLEGE

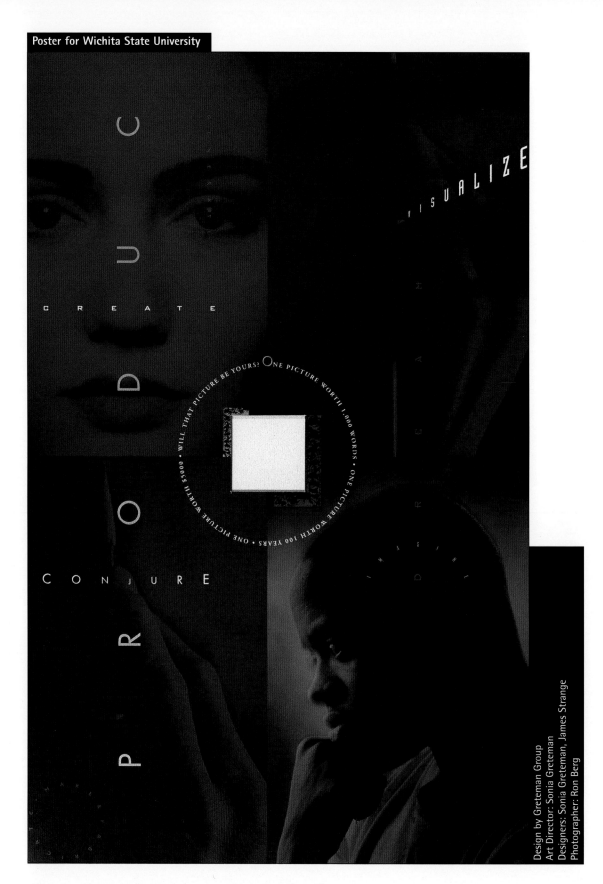

With its dusky shades of brown, purple, and gray, this
poster advertising a fine-arts competition draws
viewers into a dreamlike aura that explores the
creative thought process.

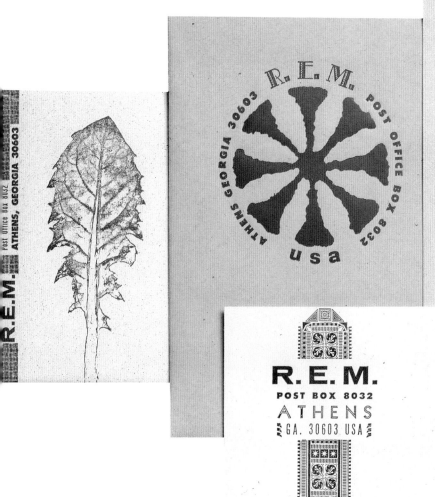

Design by Independent Project Press
Designer: Bruce Licher

The Independent Project Press and the rock band R.E.M.

share an aesthetic sensibility and a concern for

environmental issues. These special Christmas mailings to

fan club members use the IPP's letterpress printing

techniques on recycled papers with inks in earthy shades

of green, russet, and gold.

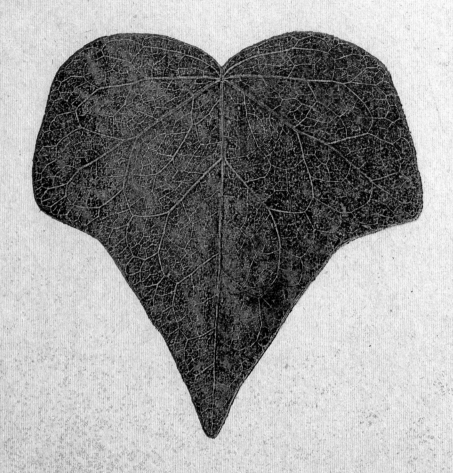

INDEPENDENT
PROJECT PRESS

544 MATEO STREET
LOS ANGELES
90013

Design by Independent Project Press
Art Directors/Designers: Bruce Licher, Karen Licher
Illustrator: Karen Licher

For the cover of a folder for the Independent Project Press, an actual leaf was run through the press and inked in a matching shade of green. The earthy tones of the paper stock and lettering give the leaf even greater prominence.

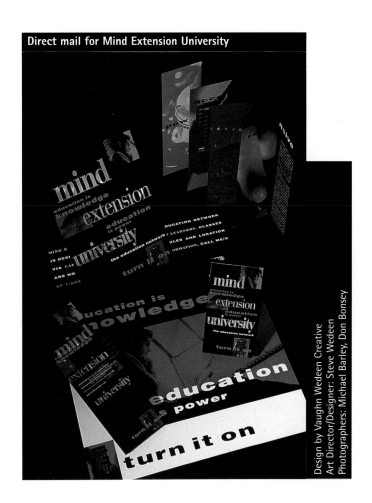

Direct mail for Mind Extension University

Design by Vaughn Wedeen Creative
Art Director/Designer: Steve Wedeen
Photographers: Michael Barley, Don Bonsey

Red draws you into these posters for an educational provider; black adds weight and seriousness; and white type gives the buzzwords and phrases their prominence.

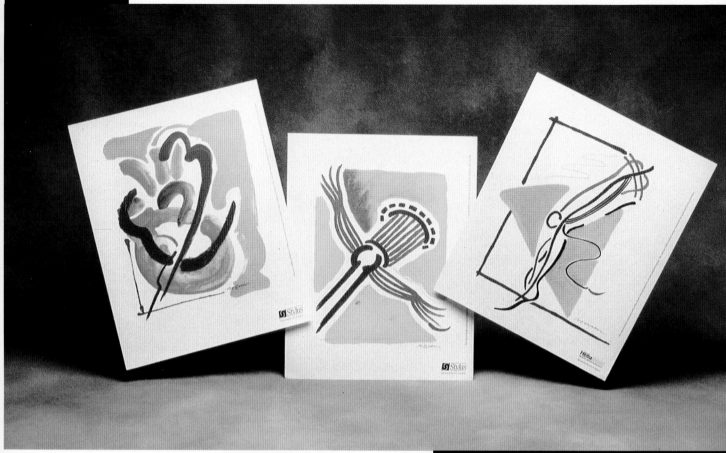

Design by Mike Quon Design Office
Art Director: Nancy Artino
Designer/Illustrator: Mike Quon

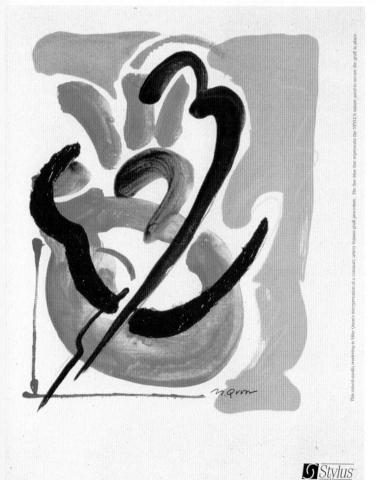

This series of posters and
displays aimed at
vascular surgeons feature
abstract illustrations of
medical-related subjects
in six shades of bold,
essentially primary colors.
The application of the
hues in brushstroke adds
to their depth and impact.

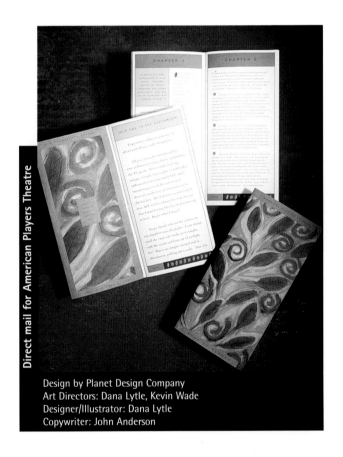

Direct mail for American Players Theatre

Design by Planet Design Company
Art Directors: Dana Lytle, Kevin Wade
Designer/Illustrator: Dana Lytle
Copywriter: John Anderson

The rich, vibrant colors of summer enliven this brochure for an outdoor theater

company. Inside, text is bordered in the same blue and yellow as the watercolor cover.

Drama often comes in the form of black-and-white. This annual report for the Progressive Corporation features a cover illustration in white ink on black paper while a variety of balancing wheels captures the eye in an interior photograph. Slight highlights in color add an element of surprise.

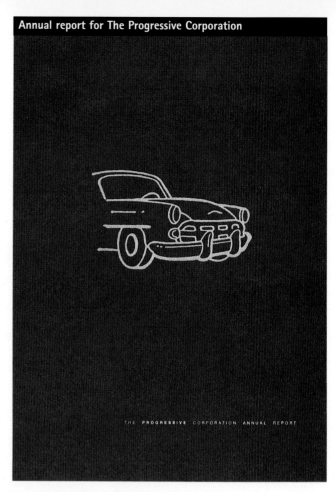

THE PROGRESSIVE CORPORATION ANNUAL REPORT

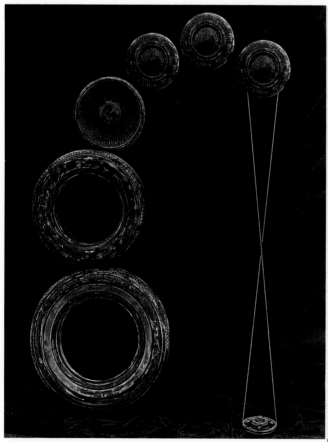

Financial Highlights 2 · 3

(millions – except per share amounts)

	1993	1992	% Change	Average Annual Compounded Rate of Increase (Decrease) 1989-1993	1984-1993
For the Year					
Direct premiums written	$ 1,966.4	$ 1,636.8	20	8	23
Net premiums written	1,819.2	1,451.2	25	7	22
Net premiums earned	1,668.7	1,426.1	17	7	21
Total revenues	1,954.8	1,738.9	12	8	22
Income before cumulative effect of accounting change	267.3	139.6	91	20	28
Net income	267.3	153.8	74	20	26
Per share:					
Income before cumulative effect of accounting change	3.58	1.85	94	24	28
Net income	3.58	2.05	75	24	26
Underwriting margin	10.7%	3.5%			
At Year-end					
Consolidated shareholders' equity	$ 997.9	$ 629.0	59	19	29
Common Shares outstanding	72.1	67.1	7	(2)	27
Book Value per Common Share	$ 12.62	$ 7.94	59	20	27
Return on average shareholders' equity	36.0%	34.7%			

Stock Price Appreciation[1]	1-Year			5-Year	10-Year
Progressive	39.8%			40.7%	28.2%
S&P 500	10.1%			14.6%	14.9%

[1]Assumes dividend reinvestment.

Wheels Triptych 1994

Design by Nesnadny + Schwartz
Art Directors: Mark Schwartz, Joyce Nesnadny
Designers: Joyce Nesnadny, Michelle Moelher, Mark Schwartz
Photographer: Zeke Berman
Illustrator: Lavy/Merriam-Webster, Inc.

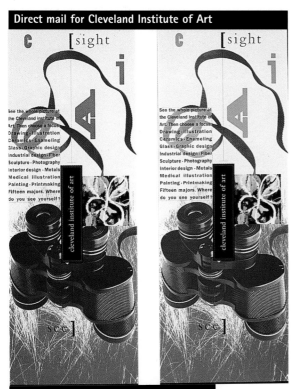

Direct mail for Cleveland Institute of Art

Design by Nesnadny + Schwartz
Art Directors: Joyce Nesnadny, Mark Schwartz
Designers: Joyce Nesnadny, Michelle Moehler
Photographer: Robert Muller, Tony Festa

While this mailer for an art institute is reissued each year, the color scheme changes to keep the graphics looking fresh. Here, the binoculars change color from teal to purple.

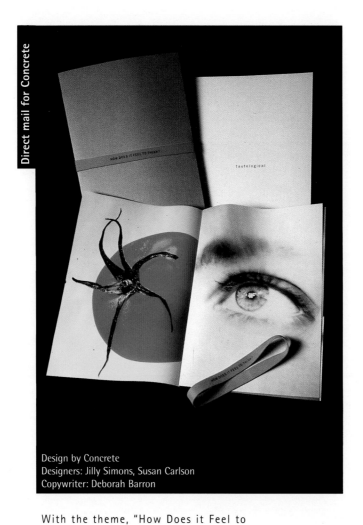

Design by Concrete
Designers: Jilly Simons, Susan Carlson
Copywriter: Deborah Barron

With the theme, "How Does it Feel to Think?" this unbound self-promotion mailer asks viewers to create visual associations of their own. In this spread, the black-and-white photograph of an eye placed next to a juicy tomato makes the fruit's almost surreal richness appear even riper.

Direct mail for Polaroid

Design by Moore Moscowitz
Art Director: Tim Moore
Designers: Jan Moscowitz,
Annette Sieblitz
Photographer: Clark Quin

The invitation to this party for Polaroid is designed to look like an opening camera aperture. The translucent vellum paper tinted in subtle shades overlaps to create soft gradations of color.

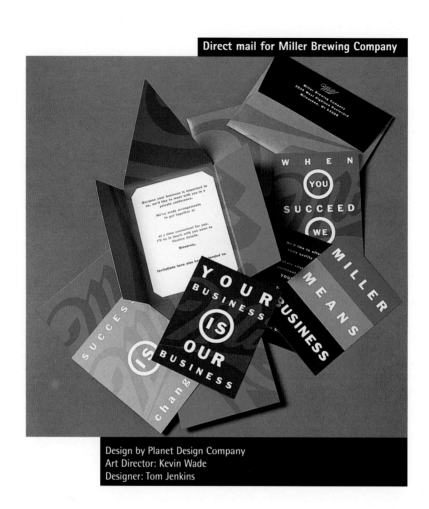

Direct mail for Miller Brewing Company

Design by Planet Design Company
Art Director: Kevin Wade
Designer: Tom Jenkins

Here, Miller Brewing Company's corporate color scheme of red, gold, and black is applied to an invitation for a business-building conference, along with sans serif type and background graphics that play on the logo. The effect shows a fresh, contemporary side of the brewery.

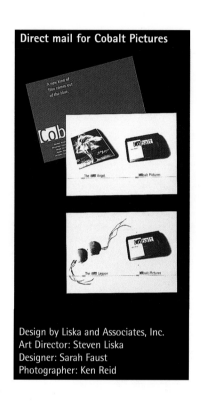

Direct mail for Cobalt Pictures

Design by Liska and Associates, Inc.
Art Director: Steven Liska
Designer: Sarah Faust
Photographer: Ken Reid

A mailer for Cobalt Pictures uses wordplay,

cobalt blue on the covers, and tinted pictures

to promote a new kind of film that "just

comes out of the blue."

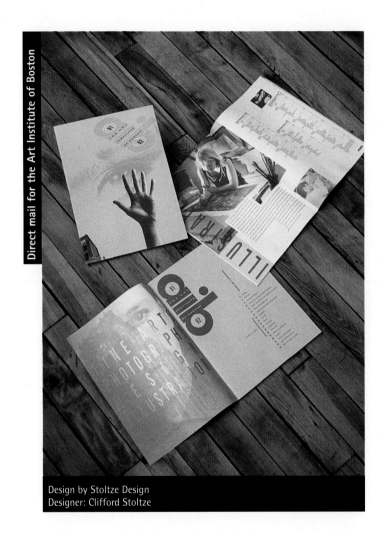

Design by Stoltze Design
Designer: Clifford Stoltze

A catalog for study programs at the Art Institute of Boston creates a dreamlike ambiance illustrating the creative process through pages with softly layered photography printed in shades of blue and pink with headline text appearing in a metallic silver PMS.

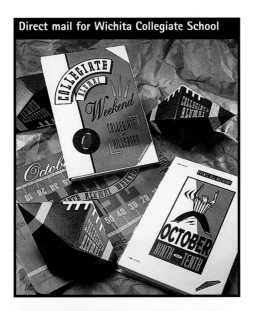

Direct mail for Wichita Collegiate School

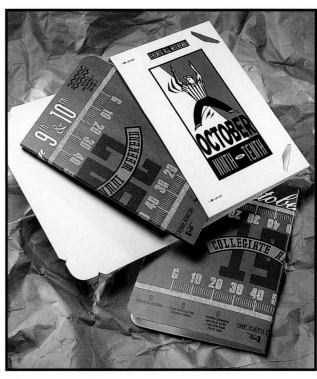

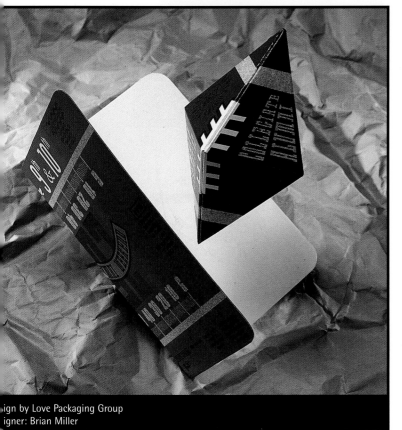

ign by Love Packaging Group
igner: Brian Miller

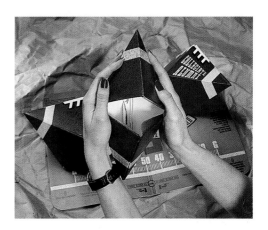

A gridiron spirit bursts out of this mailer for a collegiate alumni-weekend event. When the invitation is opened, a paper football literally pops out. The color scheme matches the gaming spirit, with a cover and interior in playing-field green, and accents in white, yellow, and brown.

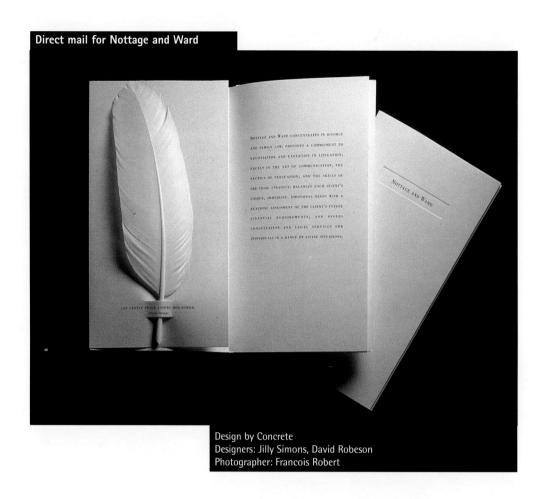

Direct mail for Nottage and Ward

Design by Concrete
Designers: Jilly Simons, David Robeson
Photographer: Francois Robert

The gentle, peaceful philosophy of this law firm is
conveyed through a mailer that soothingly reassures
with a white feather placed in a white folder, with
text set in clean boxes of justified type.

Color was used to create an optical illusion for the H. P. Zinker release, Mountains of Madness. Dual images printed in red and green are transformed when slipped in and out of the red jewel box, which acts as a decoder.

Design by Sagmeister, Inc.
Art Director: Stefan Sagmeister
Designers: Stefan Sagmeister, Veronica Oh
Photographer: Tom Schierlite

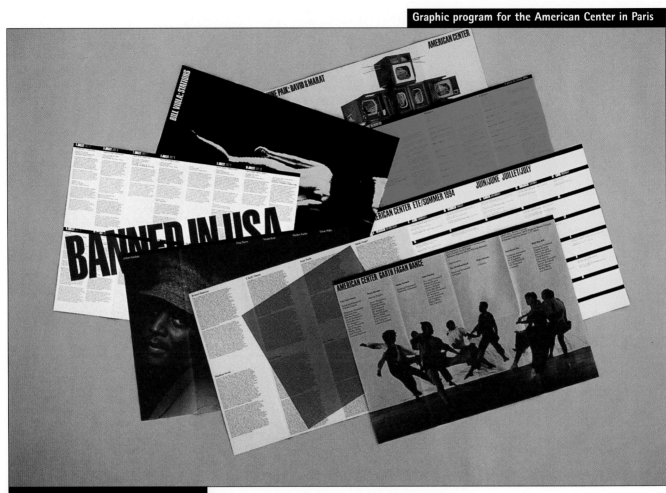

Design by Vignelli Associates, Ltd.
Art Director: Massimo Vignelli
Designers: Rebecca Rose, Chris di Maggio

To create a budget-conscious but high-impact brochure for an arts center, the design firm limited printing to two colors—black and red—on a variety of brightly-colored, lightweight papers. The transparent red ink changes hue, depending on the paper.

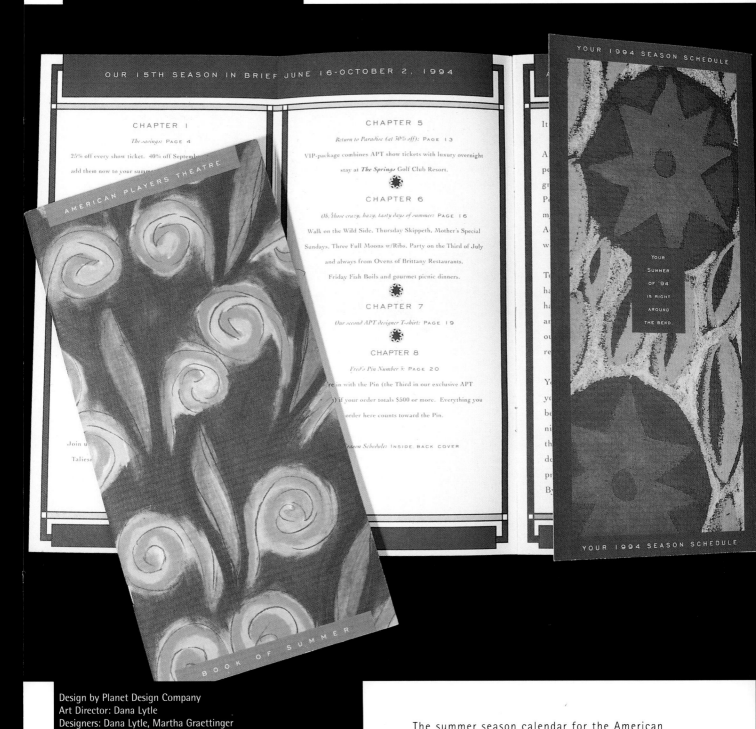

OUR 15TH SEASON IN BRIEF JUNE 16-OCTOBER 2, 1994

CHAPTER 1

The savings: PAGE 4

25% off every show ticket. 40% off September

add them now to your summer

CHAPTER 5

Return to Paradise (at 50% off): PAGE 13

VIP-package combines APT show tickets with luxury overnight

stay at *The Springs* Golf Club Resort.

CHAPTER 6

Oh, those crazy, hazy, tasty days of summer: PAGE 16

Walk on the Wild Side, Thursday Skippeth, Mother's Special

Sundays, Three Full Moons w/Ribs, Party on the Third of July

and always from Ovens of Brittany Restaurants,

Friday Fish Boils and gourmet picnic dinners.

CHAPTER 7

Our second APT designer T-shirt: PAGE 19

CHAPTER 8

Fred's Pin Number 3: PAGE 20

re in with the Pin (the Third in our exclusive APT

) if your order totals $500 or more. Everything you

order here counts toward the Pin.

eason Schedule: INSIDE, BACK COVER

AMERICAN PLAYERS THEATRE

BOOK OF SUMMER

YOUR 1994 SEASON SCHEDULE

YOUR SUMMER OF '94 IS RIGHT AROUND THE BEND.

YOUR 1994 SEASON SCHEDULE

Design by Planet Design Company
Art Director: Dana Lytle
Designers: Dana Lytle, Martha Graettinger
Illustrator: Dana Lytle

The summer season calendar for the American
Players Theatre bursts to life with a cover
illustration in rich floral tones and interior pages
accented with color bars in purple, red, and yellow.

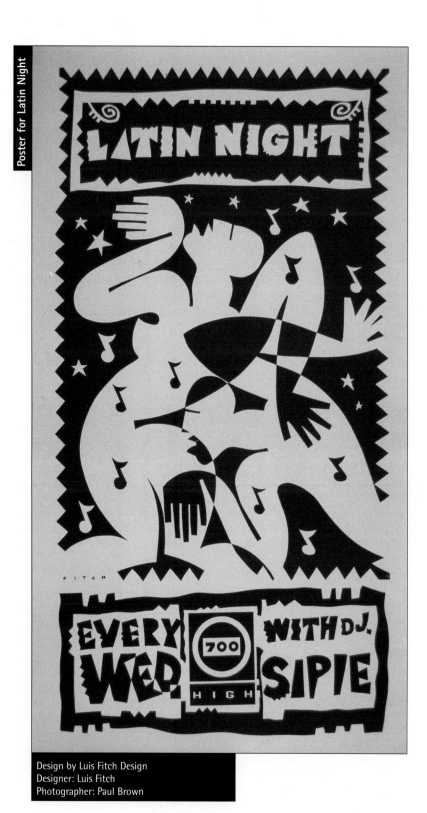

Design by Luis Fitch Design
Designer: Luis Fitch
Photographer: Paul Brown

This poster for a Latin Night at a club sizzles with energy from its silk-screened, woodcut-like image printed in high-contrast red ink on yellow paper.

Football poster for Houlihan's

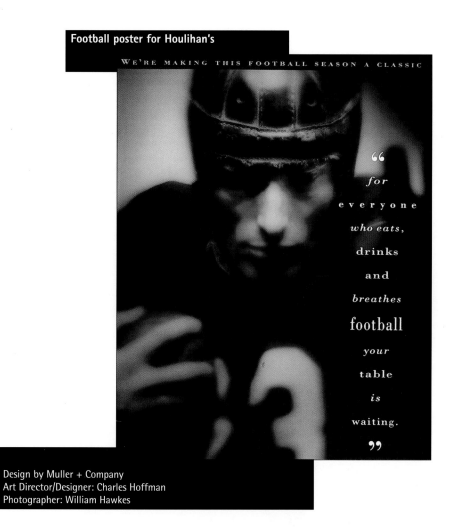

WE'RE MAKING THIS FOOTBALL SEASON A CLASSIC

" *for* **everyone** *who eats,* **drinks** **and** *breathes* **football** *your* **table** *is* **waiting.** "

Design by Muller + Company
Art Director/Designer: Charles Hoffman
Photographer: William Hawkes

A burnished look was given to this softly-focused, almost surreal image of an old-time football player on a poster that was printed in shades of black and gold.

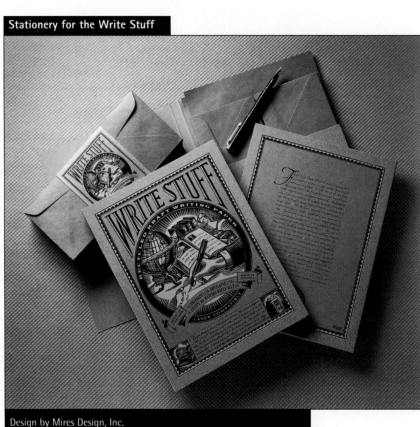

Stationery for the Write Stuff

Design by Mires Design, Inc.
Art Director/Designer: José Serrano
Illustrator: Tracy Sabin

The eco-friendly composition of this recycled kraft writing paper product is highlighted with a sophisticated line drawing in black depicting scholarly desktop accoutrements.

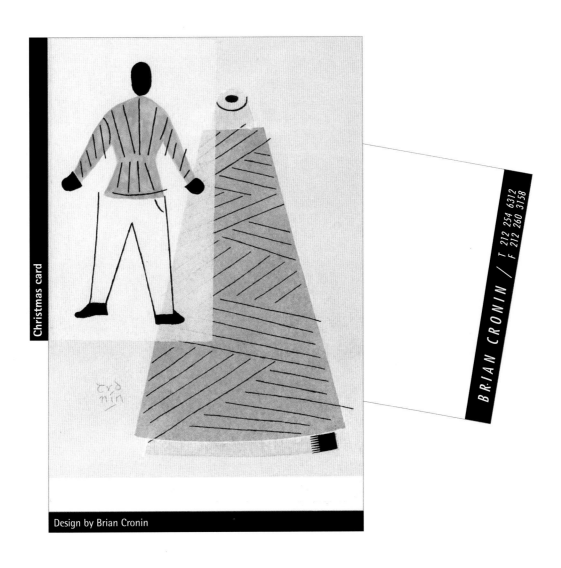

Christmas card

Design by Brian Cronin

BRIAN CRONIN / T 212 254 6312 F 212 260 3758

"Stay Warm," says this holiday greeting with an illustration depicting a cone of wool as a Christmas tree and a person wearing a sweater of the same evergreen color.

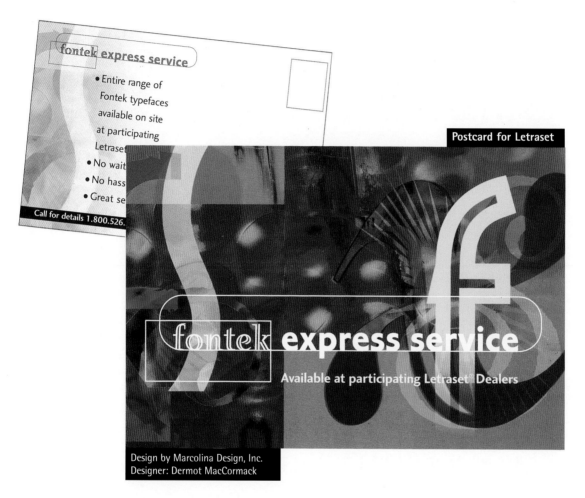

fontek express service

• Entire range of
 Fontek typefaces
 available on site
 at participating
 Letraset
• No wait
• No hass
• Great se

Call for details 1.800.526.

Postcard for Letraset

fontek express service

Available at participating Letraset® Dealers

Design by Marcolina Design, Inc.
Designer: Dermot MacCormack

A montage of
shapes and letter
forms in vibrant
colors creates an
unmistakable
energy on this
postcard
introducing
Letraset's Fontek
Express service.

Do the math! Buy two units of Sidekick 95, the #1 best-selling personal organizer, and get an NFR Dashboard 95 free! (or vice-versa) They're both 100% Windows 95 compliant and 100% 32-bit native. But hurry, this is a limited time offer! Call your distributor now!

INGRAM MICRO

1-800-456-8000
Limit one per reseller location.

1600 E. St. Andrew Place
P.O. Box 25125
Santa Ana, CA 92799-5125

FIRST CLASS MAIL
U.S. POSTAGE
PAID
M & M INC.

Design by Free-Range Chicken Ranch
Art Director/Designer: Kelli Christman
Photographer: Jeff Becker

Starfish Software™

now shipping!

Just buy two Starfish Software Windows® 95 applications, and get one free. Get it?

one, two, free!

(what are you waiting for??!!)

Playfully confrontational text and graphics draw attention to this postcard for a software giveaway. Large-scale type in brown, and a yellow background image of a screaming man, add to the volume. The postcard was also printed in fuchsia and black.

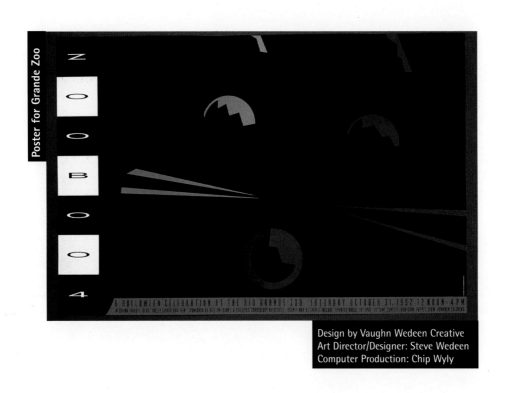

Poster for Grande Zoo

ZOOBOO4

A HALLOWEEN CELEBRATION AT THE RIO GRANDE ZOO. SATURDAY OCTOBER 31, 1992 12 NOON 4 PM

Design by Vaughn Wedeen Creative
Art Director/Designer: Steve Wedeen
Computer Production: Chip Wyly

Minimalist applications of
brilliant color on a black
background form this abstract
illustration of a black cat on a
poster for a Halloween event
at a zoo. Orange type
continues the holiday theme,
while a headline in a vertical
black-and-white band adds
balance and contrast.

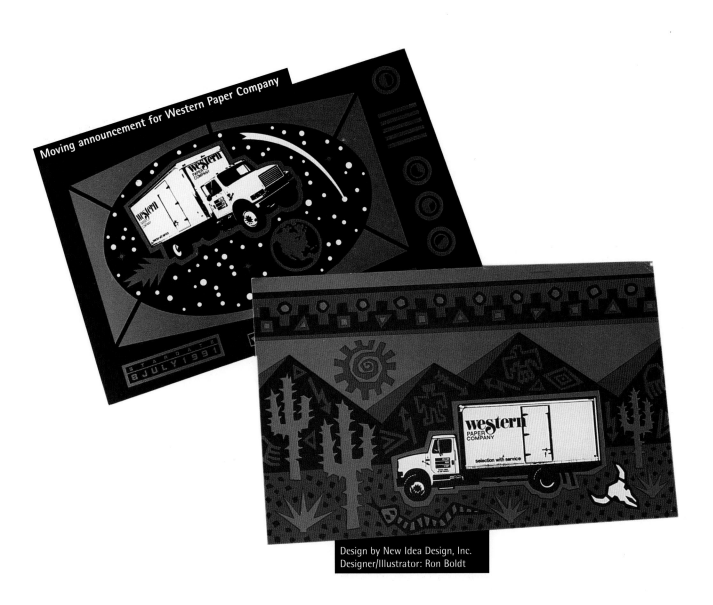

Moving announcement for Western Paper Company

Design by New Idea Design, Inc.
Designer/Illustrator: Ron Boldt

Moving announcements for the Western Paper
Company portray the company as being on the
move: The company truck appears within an
American West motif in desert colors, and as a
playful space rocket design in nighttime shades
of black, gray, gold, and white.

BIG DAY. Thursday, November 5, during this year's ICSC Deal Making Convention in Dallas, Gary Shafer and the retail partners of Trammell Crow Company invite you to a special after-hours party. It's a great way to end a big day.

BIG TIME. That evening from 7:30 P.M. to 10:30 P.M. we'll host a buffet and cocktails. Transportation to the party will be provided from the Anatole Hotel, Chantilly Entrance, at 7:15, 7:30 and 7:45 P.M., with return service every fifteen minutes. So make plans to have a great time with us.

Design by SullivanPerkins
Art Director: Ron Sullivan
Designer/Illustrator: Michael Sprong

"Big" was the theme of this invitation to an after-hours party held in conjunction with a business convention, with "Big Day" illustrated with an oversized calendar and "Big Time" with a large watch face. This was not an occasion to use soft colors: big shades of orange, red, and green were selected.

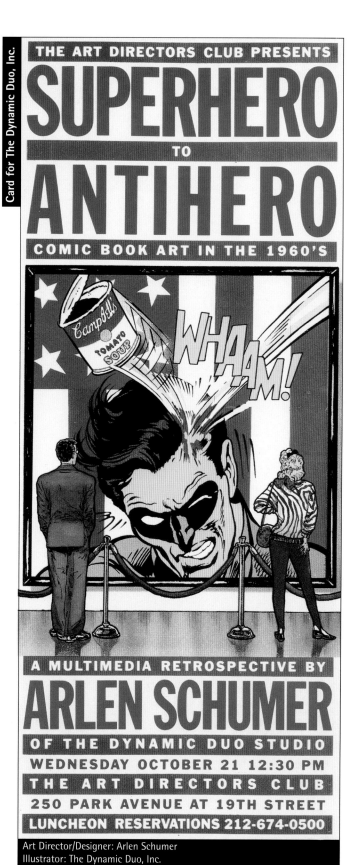

THE ART DIRECTORS CLUB PRESENTS

SUPERHERO
TO
ANTIHERO

COMIC BOOK ART IN THE 1960'S

A MULTIMEDIA RETROSPECTIVE BY

ARLEN SCHUMER

OF THE DYNAMIC DUO STUDIO
WEDNESDAY OCTOBER 21 12:30 PM
THE ART DIRECTORS CLUB
250 PARK AVENUE AT 19TH STREET
LUNCHEON RESERVATIONS 212-674-0500

Art Director/Designer: Arlen Schumer
Illustrator: The Dynamic Duo, Inc.
Design & Line Art: Arlen Schumer
Color: Sherri Wolfgang

Wham!
A star-spangled flag motif in red, white, and blue puts an all-American spin on a speaker luncheon event about comic-book art in the 1960s by illustrator/historian Arlen Schumer.

click or drag on any area of the image bar to explore the portfolio

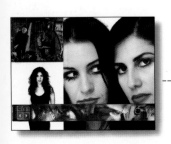

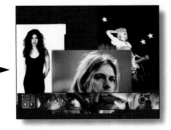

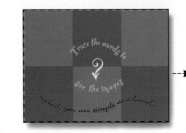

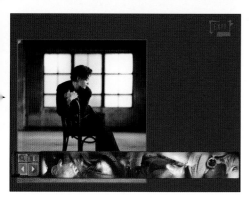

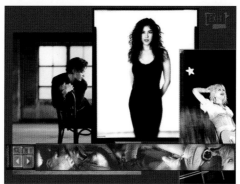

The distinct styles of each of these photographers is enhanced by an appropriate color scheme in their digital portfolios. For MTV photographer Frank Micelotta, a somber black background sets up the realistic, sometimes gritty shots of rock musicians, and provides contrast to the colorful scrolling images on the bottom of the screen. A pale-green marbleized background with white type creates a soft simplicity for the romantic images of Joyce Tenneson, while a vibrant green-and-purple checkerboard pattern sets up the zany, computer-enhanced images of Michel Tcherevkoff.

Design by WOW Sight + Sound
Photography: Frank Micelotta, Joyce Tenneson, Michel Tcherevkoff
Designers: Abby Mufson, John Fezzuoglio, Darell Dingerson
Programmers: Abby Mufson, Alec Cove

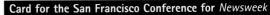

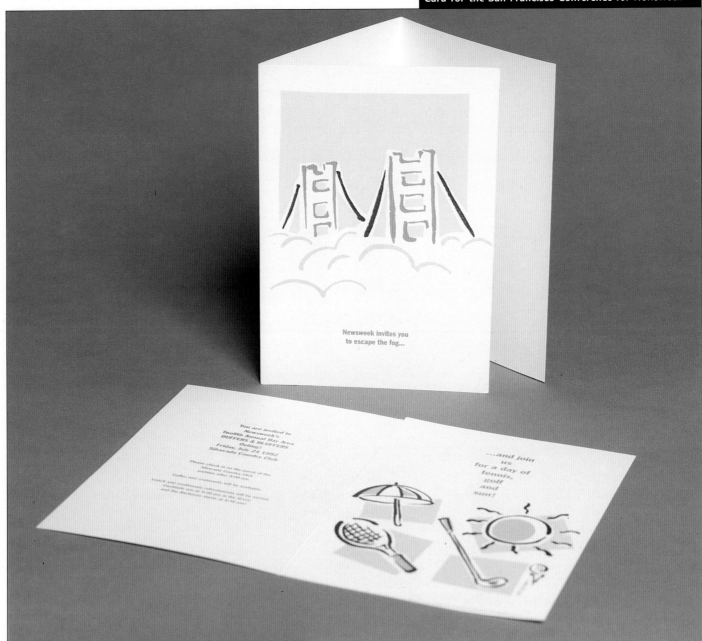

Newsweek invites you
to escape the fog...

...and join
us
for a day of
tennis,
golf
and
sun!

Design by Mike Quon Design Office
Art Director: Tracy Stars
Designer/Illustrator: Mike Quon

Pure escapism is found in the cool greens and

lavenders of this invitation to relax from work

at a golf and tennis outing.

Graphics system for Converse basketballs

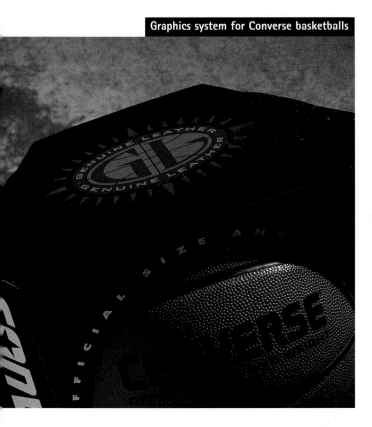

Design by Swieter Design
Art Director: John Swieter
Designers: John Swieter, Kevin Flatt, Paul Munsterman

A black background appearing on Converse's basketball packaging conveys a serious, professional quality. Key features of the balls are called out in logos incorporating basketball seams in bright shades of red, green, purple, and yellow.

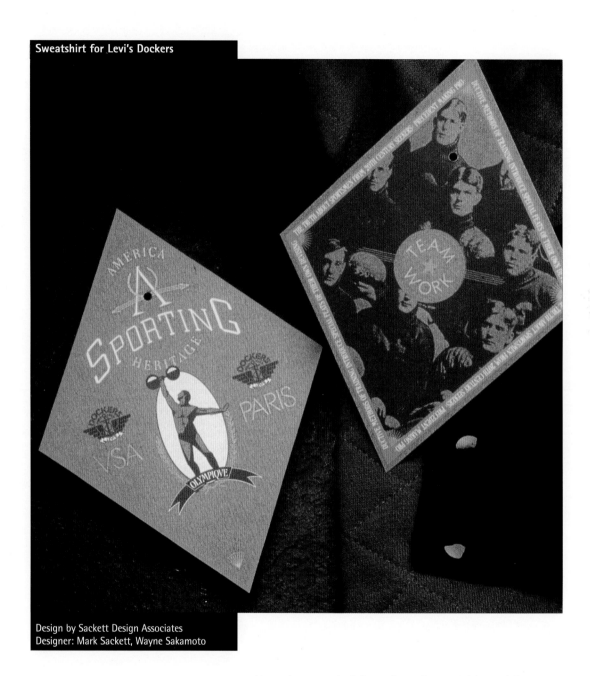

Sweatshirt for Levi's Dockers

Design by Sackett Design Associates
Designer: Mark Sackett, Wayne Sakamoto

Hang tags created for a line of sweatshirts with a turn-of-the-century sporting club theme reflect the nostalgic spirit with a sepia-toned image of a rugby team printed on gray paper. Logos appear on the reverse side on a matte gold background. Aqua borders on both sides add a contemporary touch.

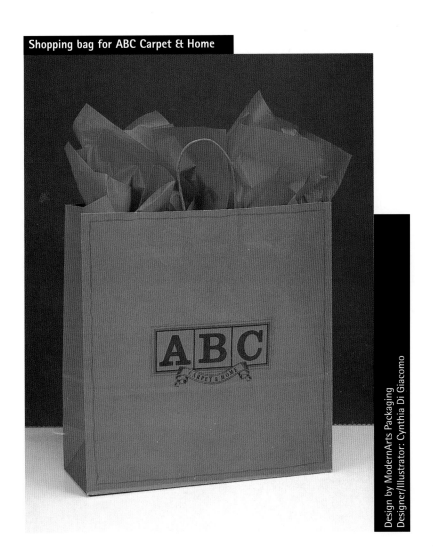

Shopping bag for ABC Carpet & Home

Design by ModernArts Packaging
Designer/Illustrator: Cynthia Di Giacomo

The ABC Carpet & Home department store in New York offers everything from conservative Oriental rugs to funky hand-blown stemware. These shopping bags reflect that diversity of style with a traditional serif logo printed on natural kraft paper and edged in a hand-drawn fuchsia border.

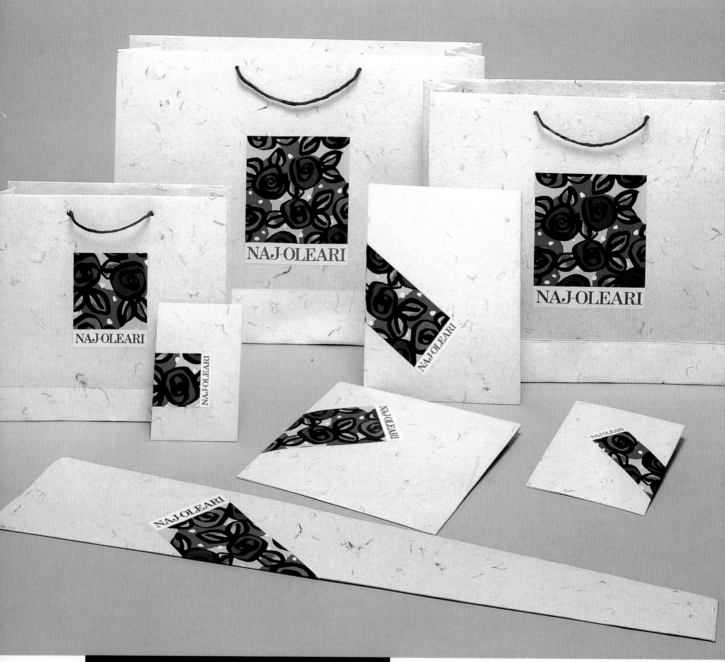

Design by Angelo Sganzerla
Art Director/Designer: Angelo Sganzerla
Illustrator: Maurizia Dova

Naj-Oleari produces colorful cotton clothes. The company's packaging features a label in a riot of primary and secondary colors applied on handmade paper embedded with cotton threads of many hues.

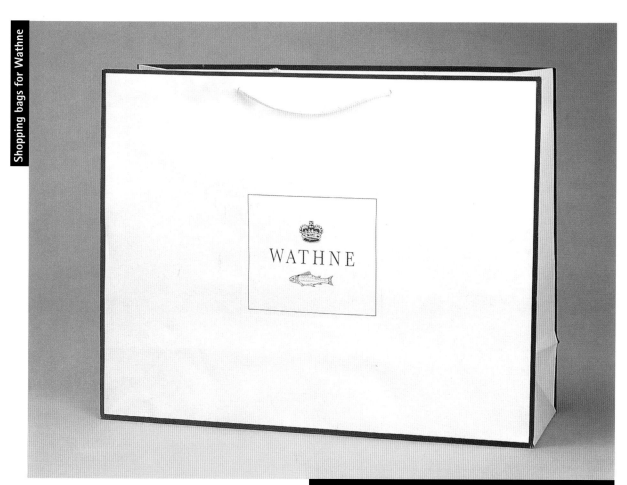

Bag Manufacturer: ModernArts production facility

This elegantly understated shopping-bag design for Wathne is bordered in green; during the winter holidays, the bag is trimmed in gold.

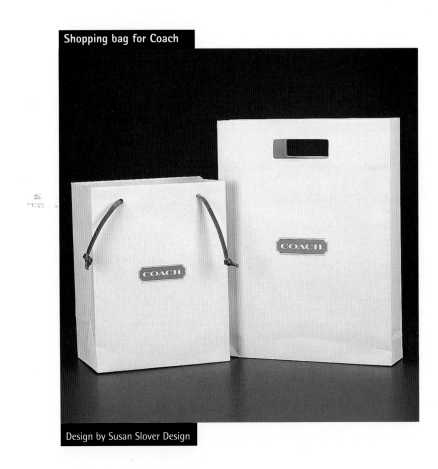

Shopping bag for Coach

Design by Susan Slover Design

Coach makes leather goods in many colors, but their trademark color is chestnut brown. Here, the logo appears in that shade on a cream-colored paper stock. Durable chestnut leather handles are a whimsical matching touch.

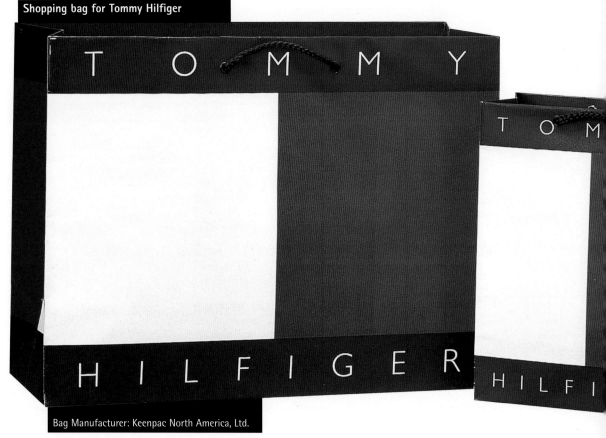

Shopping bag for Tommy Hilfiger

Bag Manufacturer: Keenpac North America, Ltd.

Tommy Hilfiger's all-American style appears on shopping bags sporting a red, white, and blue motif in the same large color blocks that regularly crop up in his clothing designs.

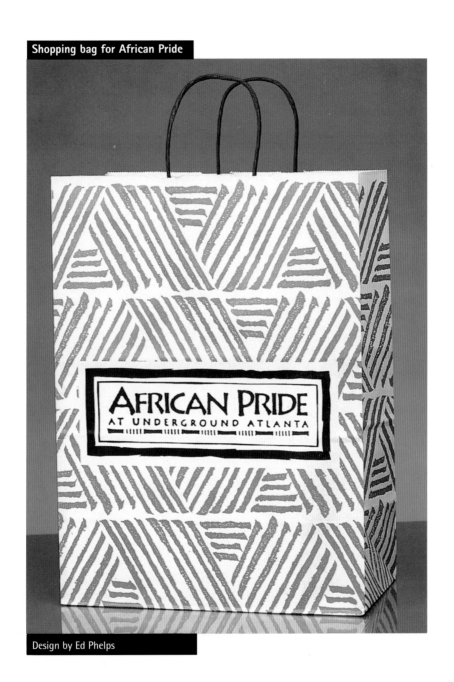

This African Pride shopping bag employs a primitive, hand-drawn pattern in a striking color scheme of brown printed on cream paper with black type, highlighted with black handles.

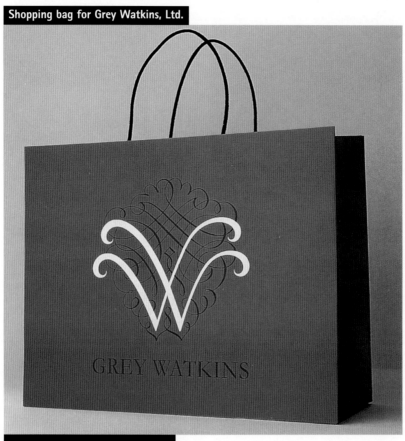

Shopping bag for Grey Watkins, Ltd.

Design by George Tscherny, Inc.
Art Director/Designer: George Tscherny
Illustrator: Lynne Buchman

Gray Watkins, Ltd. manufactures decorative fabrics with traditional design influences. The regal store logo—a *W* based on a flourished Victorian typeface—is matched by the bag's imperial purple paper.

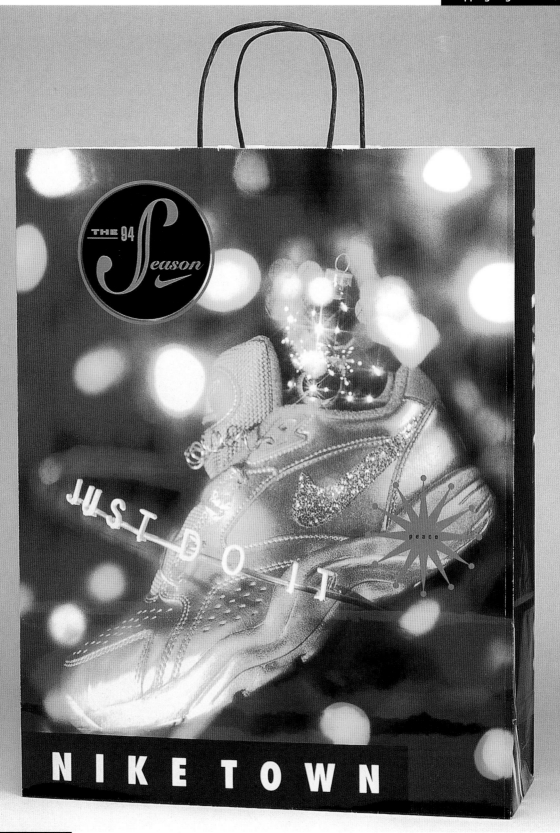

Holiday shopping bags for Niketown carry the glow of the season with
images of ornamented shoes in saturated holiday colors of red and gold.
The black-and-white logo provides a relief from the visual overload.

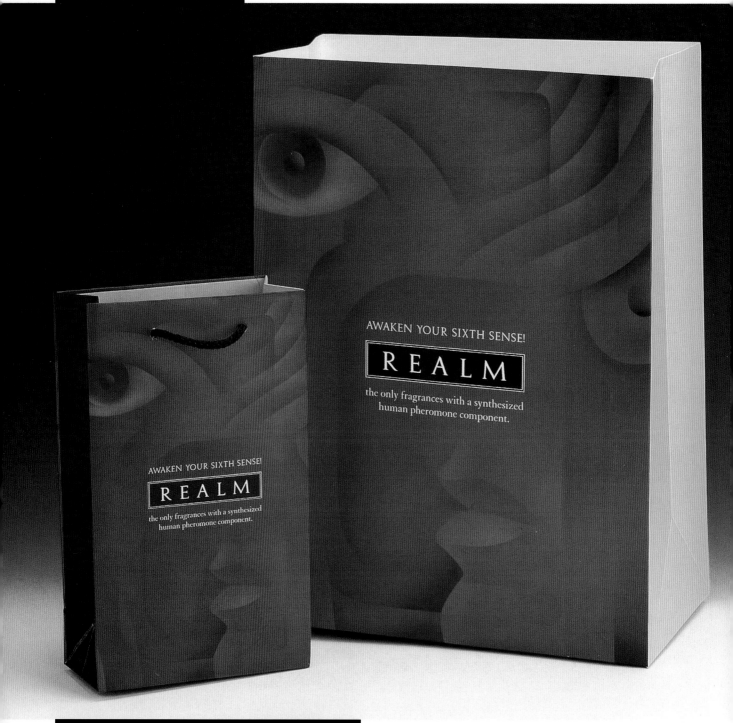

AWAKEN YOUR SIXTH SENSE!

R E A L M

the only fragrances with a synthesized
human pheromone component.

Design by 1185 Design
Art Director/Designer: Andy Harding

Red is often used to convey passion and energy in fragrance packaging and advertising. These shopping bags for a fragrance that employs a human pheromone use red to bring out the product's heady, sensual pleasures.

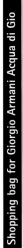
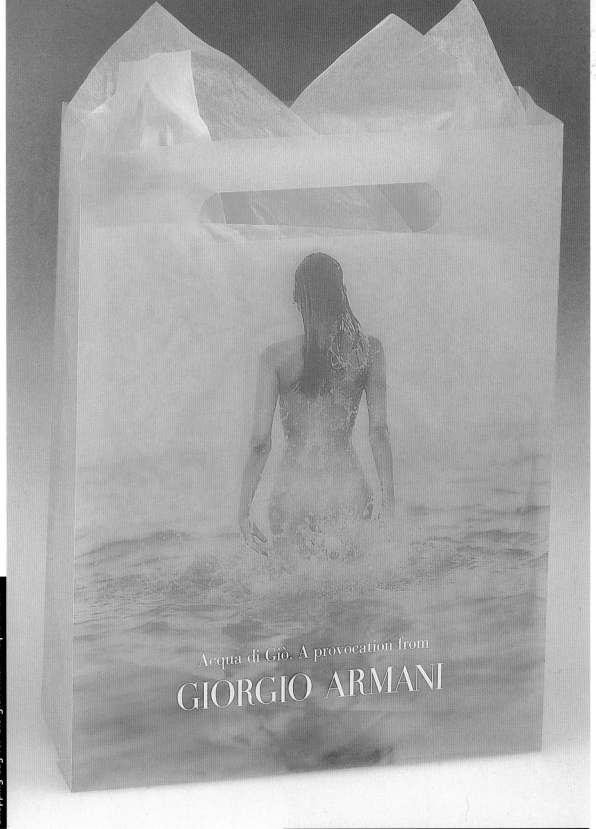

Acqua di Giò. A provocation from
GIORGIO ARMANI

Design by Megan Swift

The lightness of this fragrance is emphasized in translucent bags that reflect water's refreshing qualities with a black-and-white image of a woman wading. Aqua tissue completes the theme and makes the bag's logo emerge into view.

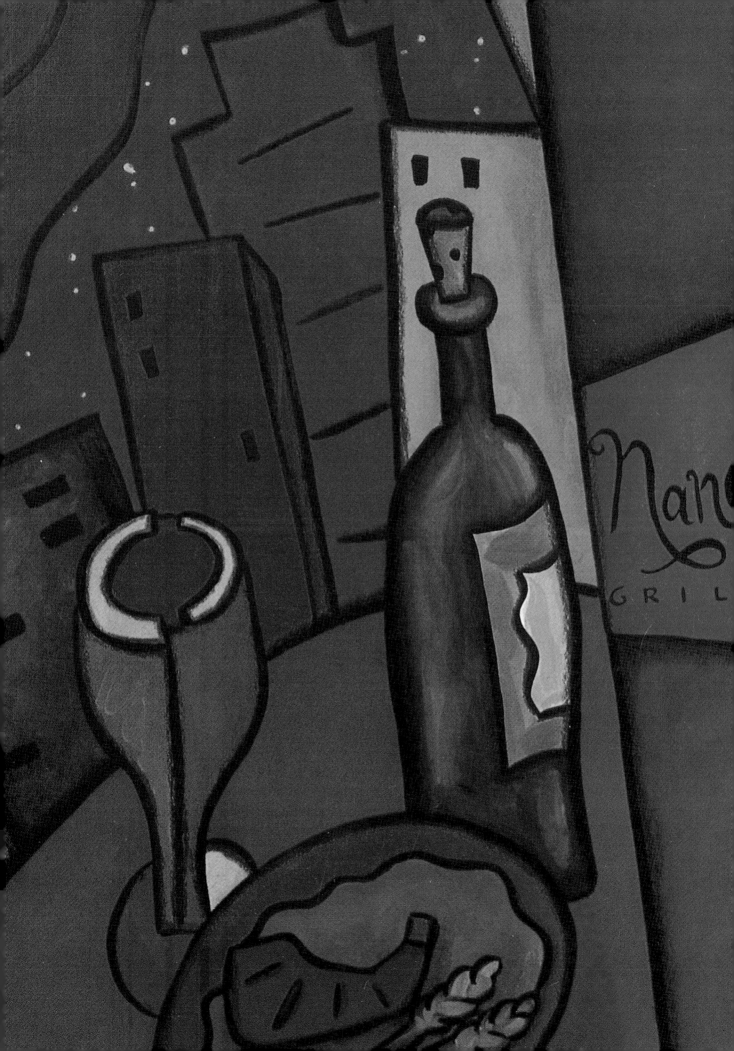

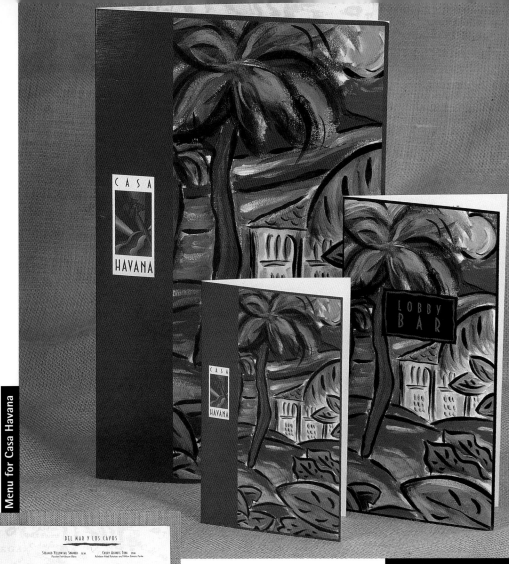

Menu for Casa Havana

Design by Associates Design
Art Director: Chuck Polonsky
Designer: Mary Greco

This menu design for a Cuban-themed
hotel restaurant recreates the
brilliant colors of an island sunset in
a watercolor of a mansion amidst
tropical foliage.

Menu for Nana Grill

The menu design for Nana Grill is the portrait of urban
sophistication with a watercolor still life of a table
setting and a starry night painted in rich, dusky hues.

Design by Associates Design
Art Director: Chuck Polonsky
Designer/Illustrator: Jill Arena

Warm earth tones for ink and paper reflect the restaurant's primitive interior design theme. This color scheme is commonly chosen by upscale coffee houses.

Design by Sayles Graphic Design
Designer: John Sayles
Photographer: Bill Neilans

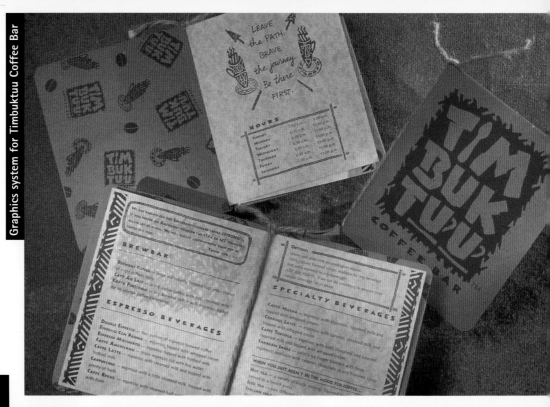

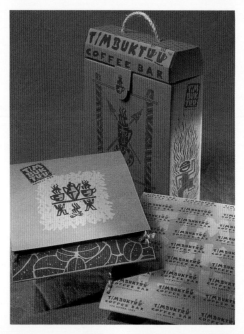

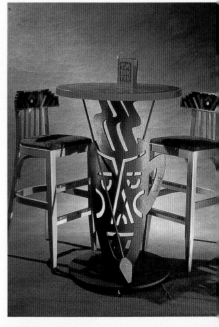

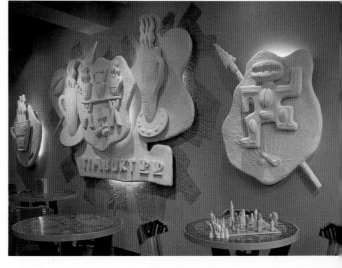

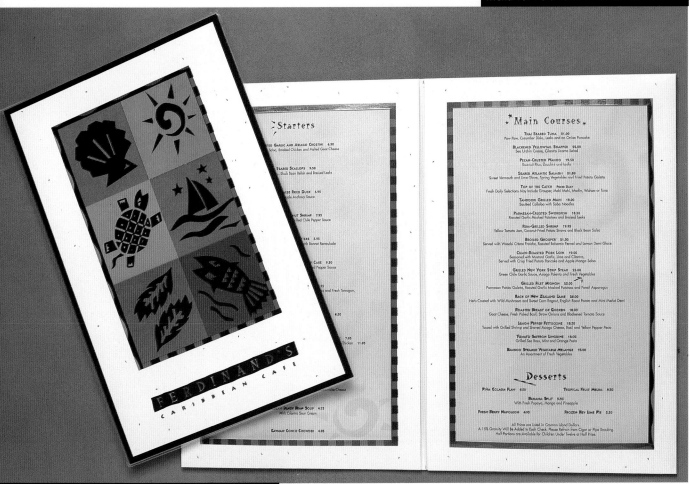

Design by Associates Design
Art Director: Chuck Polonsky
Designer/Illustrator: Jill Arena

Woodcut illustrations in a seaside
theme and printed on blocks of
tropical colors create a festive,
upbeat mood for this Caribbean cafe.
The spirit continues inside the
menus, where colors emerge subtly
through vellum overlays. The color
scheme is repeated in a banded
border.

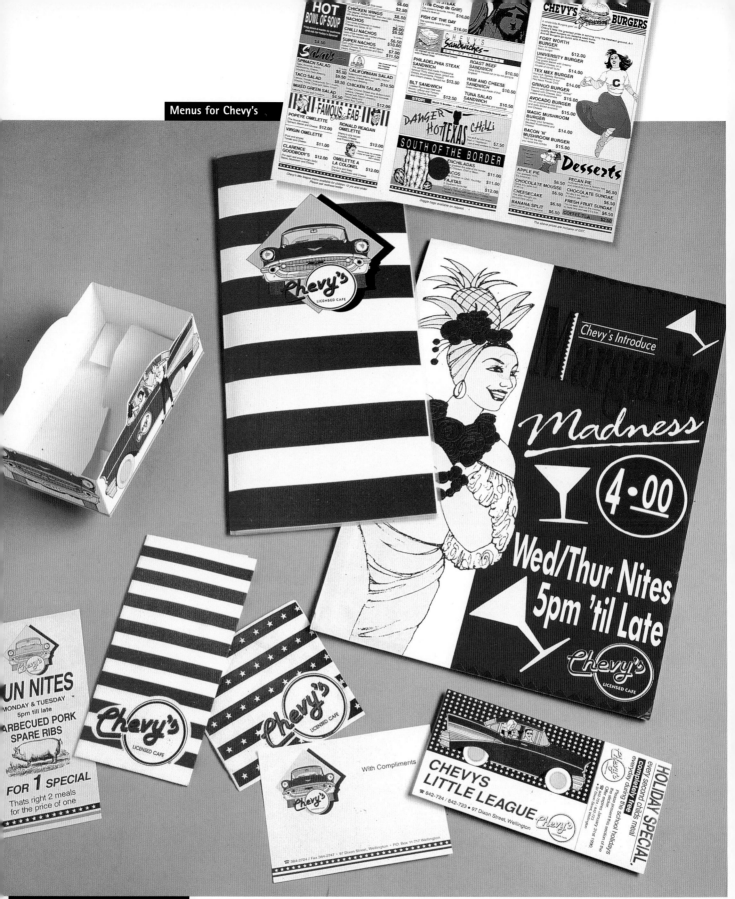

Design by Raven Madd Design Company
Art Director/Designer: Mark Curtis
Illustrators: Mark Curtis, Caroline
Campbell

A patriotic nostalgia for the 1950s is summoned in the graphics for Chevys, with American-flag colors and unwavering good cheer. The scheme works its way into special promotions, such as a holiday children's meal deal featuring a '57 Chevy against a star-spangled background.

The graphics for this menu design for a hotel restaurant in Japan create a festive atmosphere with quirky icons of flora and fauna printed in black on asymmetric shapes of bright primary and secondary colors. A logo in a futuristic typeface adds to the piece's visual zaniness.

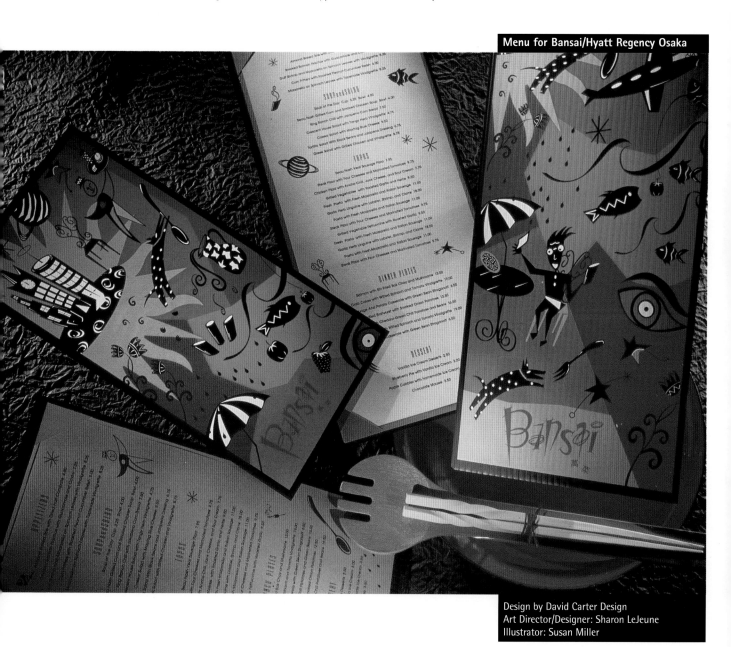

Menu for Bansai/Hyatt Regency Osaka

Design by David Carter Design
Art Director/Designer: Sharon LeJeune
Illustrator: Susan Miller

The element of surprise is
especially appropriate for a poster
promoting a Halloween event.
Here, a tiger's muted shades of
black and gold draw attention to
his scarlet-and-purple mask. Boo!

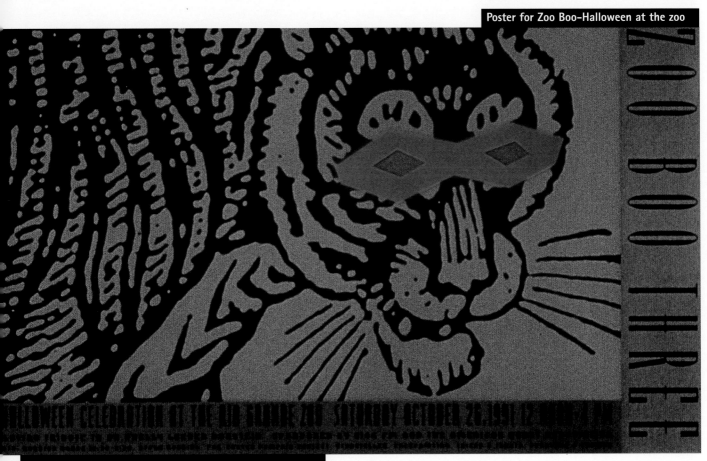

Poster for Zoo Boo–Halloween at the zoo

Design by Vaughn Wedeen Creative
Art Director/Designer: Steve Wedeen

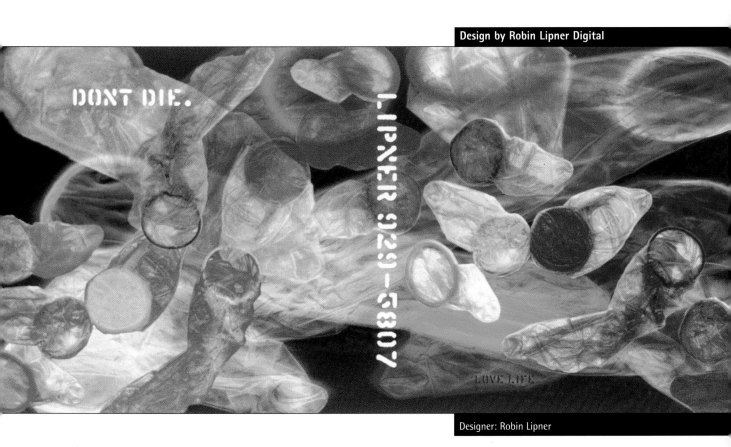

Design by Robin Lipner Digital

DONT DIE.

LIPNER 929-5807

LOVE LIFE

Designer: Robin Lipner

The boisterous colors of these condoms provide an ironically cheerful landscape for this ad's stark anti-AIDS message. Portions of the image were inverted in Photoshop and the contrast was altered to heighten color.

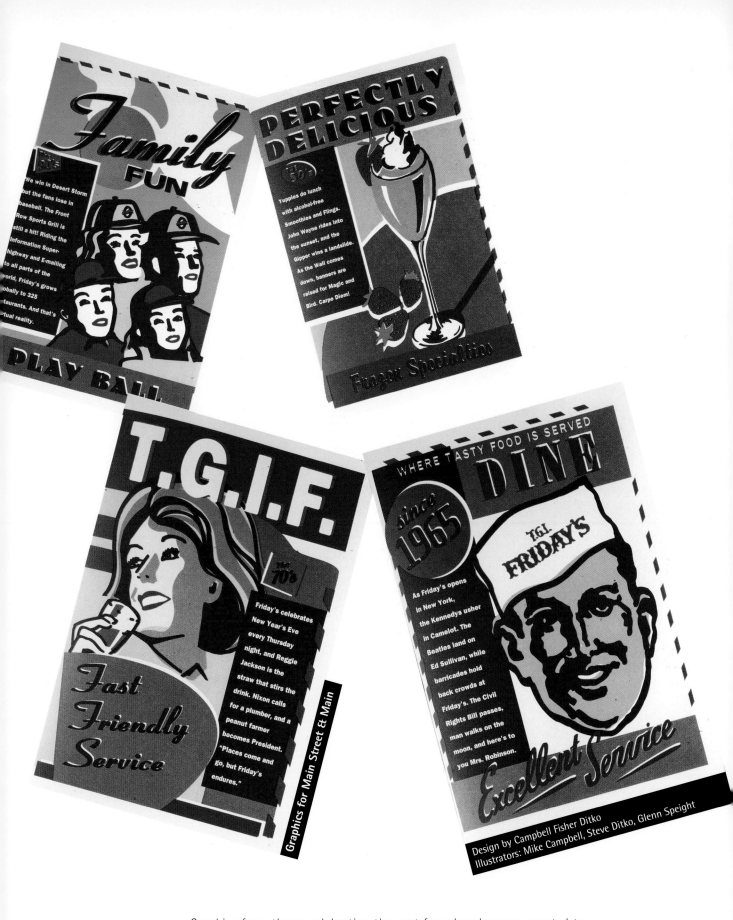

Graphics for a theme celebrating the past four decades were created to have the flat tones and offset look of old labels and matchbook art. A deliberately off-register look creates highlights and shadows in white.

Poster for Hoss Entertainment

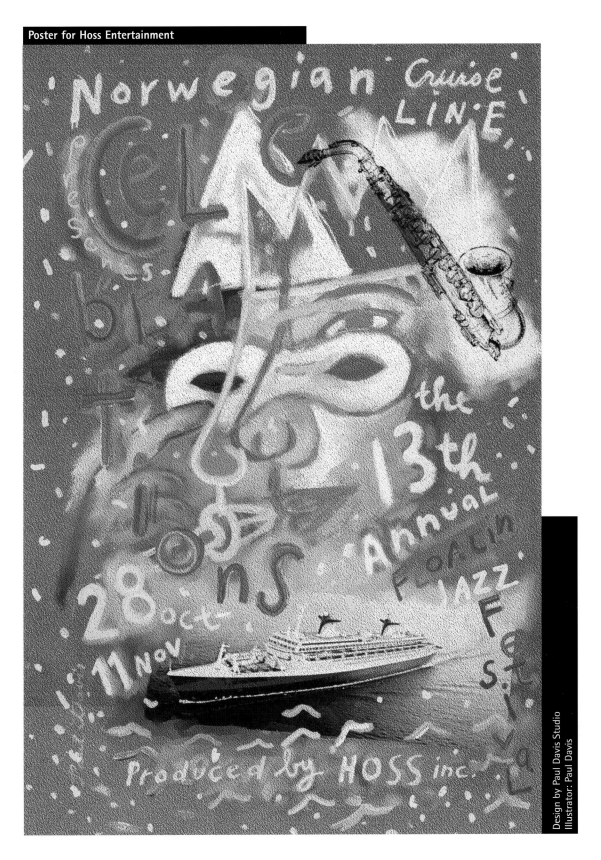

Design by Paul Davis Studio
Illustrator: Paul Davis

Paul Davis' poster promoting a jazz festival aboard a cruise ship features a painting with an improvisational flair in a color scheme that seems to light up an evening sky, complete with floating confetti, spontaneous lettering, and layered images.

Design by Blue Sky Design
Designers: Robert Little, Joanne Little, Maria Dominguez

Business card for Blue Sky Design

JOANNE C. LITTLE
Vice President & Creative Director

10300 Sunset Drive, Suite 353, Miami, Florida 33173
Telephone 305·271·2063 Facsimile 305·271·2064

The business card for Blue Sky Design
features—you guessed it—a blue sky with
fluffy clouds on one side, with a block of
solid sunny yellow on the other. A logo
designed in red assures readability.

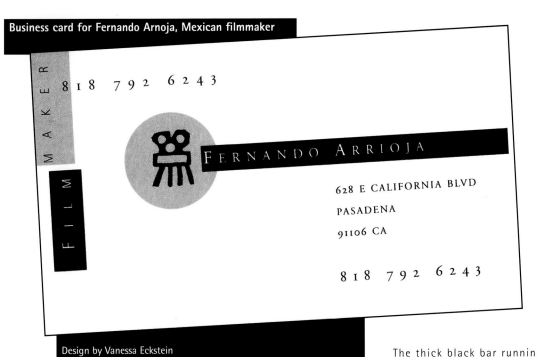

Business card for Fernando Arnoja, Mexican filmmaker

FILM MAKER

818 792 6243

FERNANDO ARRIOJA

628 E CALIFORNIA BLVD

PASADENA

91106 CA

818 792 6243

Design by Vanessa Eckstein

The thick black bar running out from a projector makes this filmmaker's name appear to be part of an opening credit sequence to a movie. Highlights in yellow draw attention to key elements.

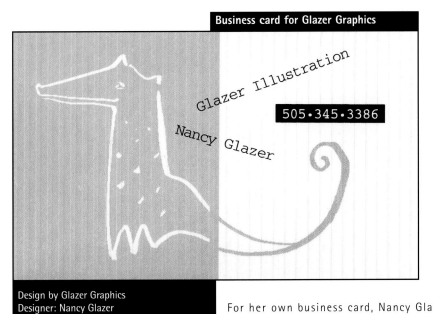

Business card for Glazer Graphics

Glazer Illustration

Nancy Glazer

505•345•3386

Design by Glazer Graphics
Designer: Nancy Glazer

For her own business card, Nancy Glazer plays with negative and positive elements, with an illustration appearing as a cream-colored line drawing on yellow on one side, and the reverse on the other.

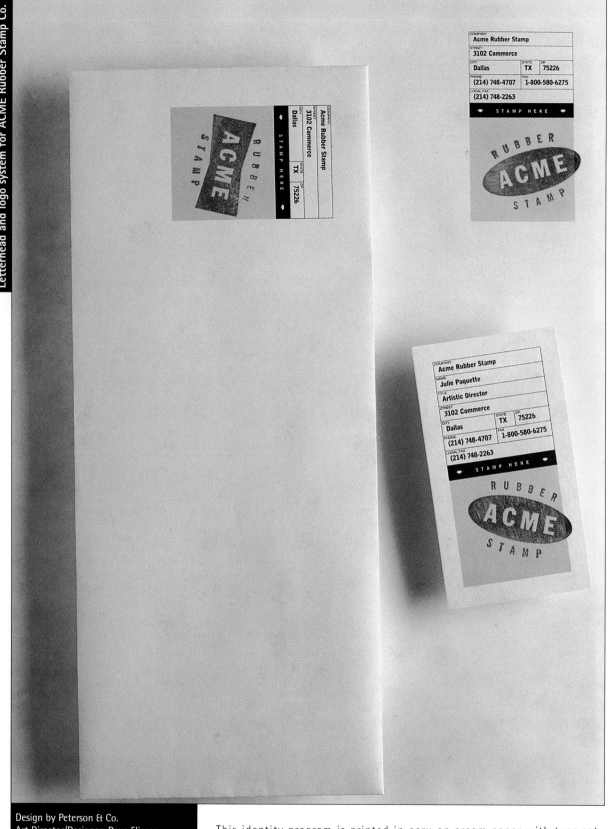

Design by Peterson & Co.
Art Director/Designer: Dave Eliason

This identity program is printed in ecru on cream paper with type set
in an industrial-looking grid format. A third color is added when the
logo is (appropriately) rubber-stamped in red ink.

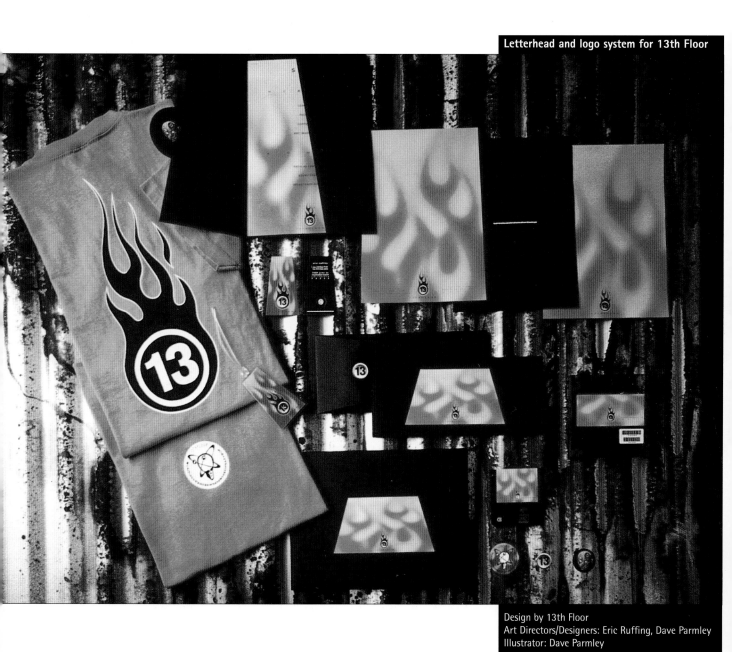

Design by 13th Floor
Art Directors/Designers: Eric Ruffing, Dave Parmley
Illustrator: Dave Parmley

Flames in orange and yellow climb seductively up
stationery and other printed pieces for 13th Floor. Added
sizzle is created when the flame labels are applied to
black backgrounds on envelopes and floppy disks.

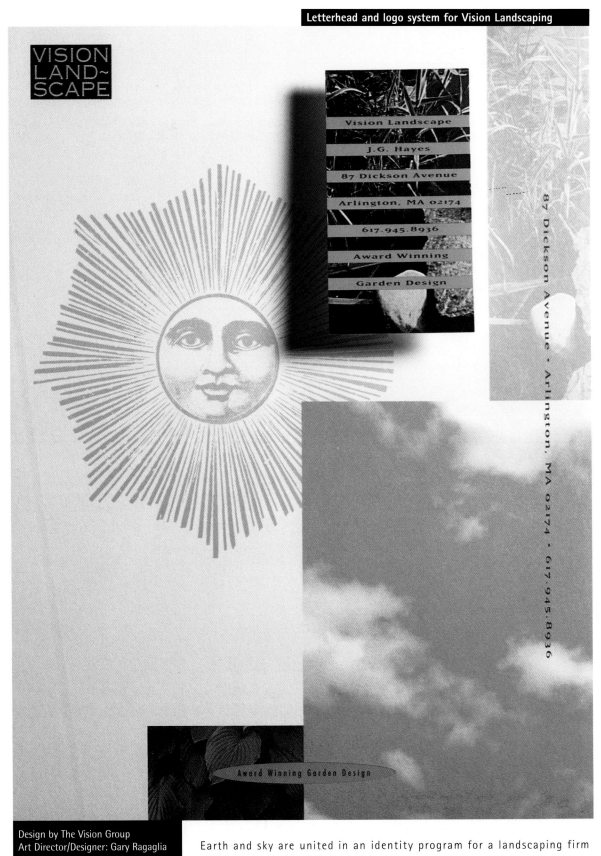

VISION
LAND~
SCAPE

Vision Landscape

J.G. Hayes

87 Dickson Avenue

Arlington, MA 02174

617.945.8936

Award Winning

Garden Design

87 Dickson Avenue · Arlington, MA 02174 · 617.945.8936

Award Winning Garden Design

Design by The Vision Group
Art Director/Designer: Gary Ragaglia

Earth and sky are united in an identity program for a landscaping firm through applications of blue and yellow on white paper. A business card is covered with rays of sun in yellow bars with black type.

P O M E G R A N A T E

Pomegranate Center is a
non-profit organization
helping communities
become culturally alive,
economically viable, and
environmentally responsible.

P O M E G R A N A T E

C E N T E R

P O M E G R A N A T E

P.O. Box 486
Issaquah, WA 98027

Tel (206) 557-6412
Fax (206) 557-4662

C E N T E R

Pomegranate Center
P.O. Box 486
Issaquah, WA 98027

Tel (206) 557-6412

Fax (206) 557-4662

Pomegranate Center
P.O. Box 486
Issaquah, WA 98027

Tel (206) 557-6412
Fax (206) 557-4662

C E N T E R

Design by Rick Eiber Design
Art Director/Designer: Rick Eiber
Illustrator: David Verwolf

The stationery for a nonprofit organization devoted to
environmental causes reflects the group's green philosophy,
and its namesake fruit, with its speckled recycled paper
and deep-red images of the pomegranate fruit.

C O M M U N I T Y

R E H A B I L I T A T I O N

C E N T E R S , I N C .

C O M M U N I T Y

R E H A B I L I T A T I O N

C E N T E R S , I N C .

Debbie Angle
Vice President

6001 Indian School Rd. NE

Albuquerque, New Mexico 87110

505 · 881 · 4961

FAX 505 · 881 · 5097

C O M M U N I T Y

R E H A B I L I T A T I O N

C E N T E R S , I N C .

22 West Monument Avenue, Suite 3 · Kissimmee, Florida 34741 · 407·847·6003 · FAX 407·847·6290

Design by Vaughn Wedeen Creative
Art Directors: Steve Wedeen, Dan Flynn
Designer/Illustrator: Dan Flynn

A soft, gentle image was created for this
rehabilitation center through an identity
program featuring a logo of a hand cradling a
flower, printed in earthy shades of forest
green, rust, and mocha brown on cream paper.

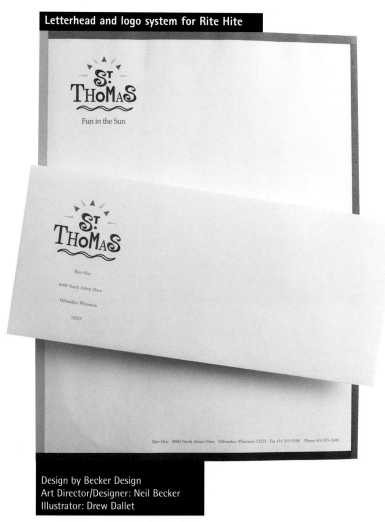

Letterhead and logo system for Rite Hite

St. Thomas
Fun in the Sun

St. Thomas

Rite-Hite

8900 North Arbon Drive

Milwaukee, Wisconsin

53223

Rite-Hite 8900 North Arbon Drive Milwaukee, Wisconsin 53223 Fax 414 355-9248 Phone 414 355-2600

Design by Becker Design
Art Director/Designer: Neil Becker
Illustrator: Drew Dallet

To promote an incentive program offering a trip to St. Thomas, special stationery was created that reflects the festive mood of the island, with a lively logo in a variety of typefaces and colors and borders in bands of orange, yellow, green, and blue.

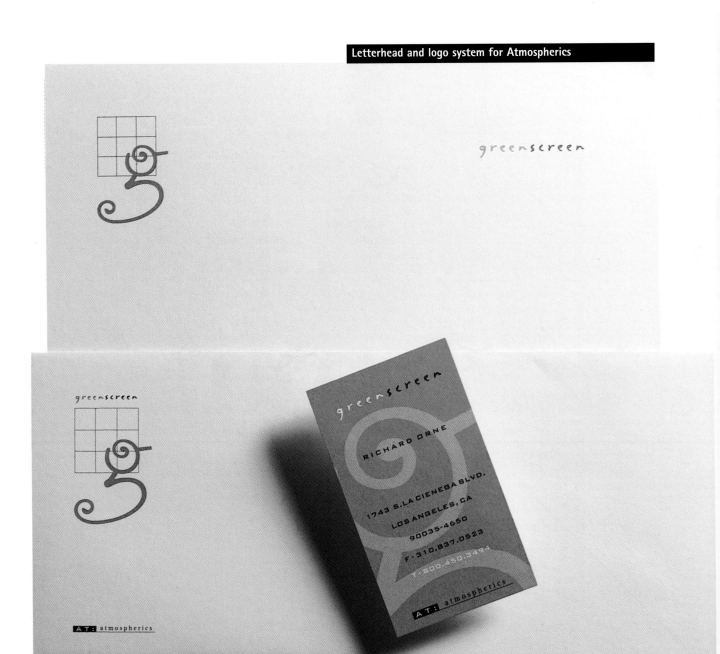

Design by Clifford Selbert Design
Art Director: Robin Perkins
Designer: Heather Watson

Two shades of green are applied to identity pieces
Green Screen, a landscaping firm, to play on the
company name. Business cards, for example, featu
the distinctive *g* in a "screened" light green printe
on a darker shade.

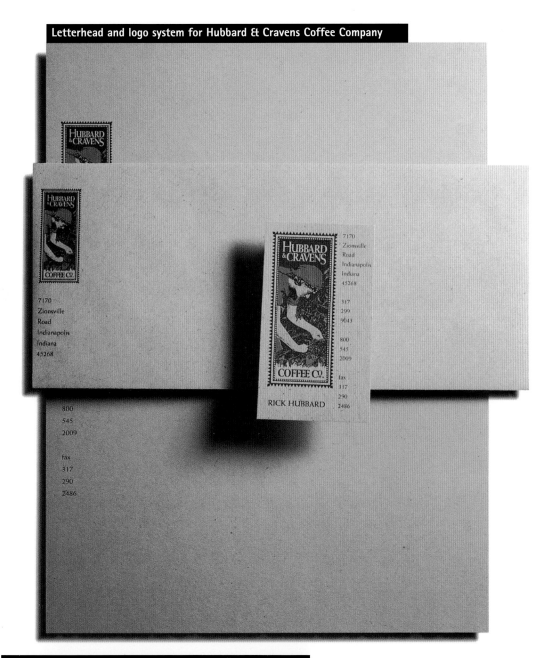

Letterhead and logo system for Hubbard & Cravens Coffee Company

HUBBARD
&CRAVENS

HUBBARD
&CRAVENS

COFFEE CO.

7170
Zionsville
Road
Indianapolis
Indiana
45268

800
545
2009

fax
317
290
2486

HUBBARD
&CRAVENS

COFFEE CO.

RICK HUBBARD

7170
Zionsville
Road
Indianapolis
Indiana
45268

317
299
9043

800
545
2009

fax
317
290
2486

Design by Kelly O. Stanley Design
Designer: Kelly O'Dell Stanley

The color scheme of this stationery program for a coffee
distributor creates a look of antiquity, with a hand-
colored image of a 1920s coffee harvester printed on
natural recycled paper.

Letterhead and logo system for Glen Rogers Perrotto

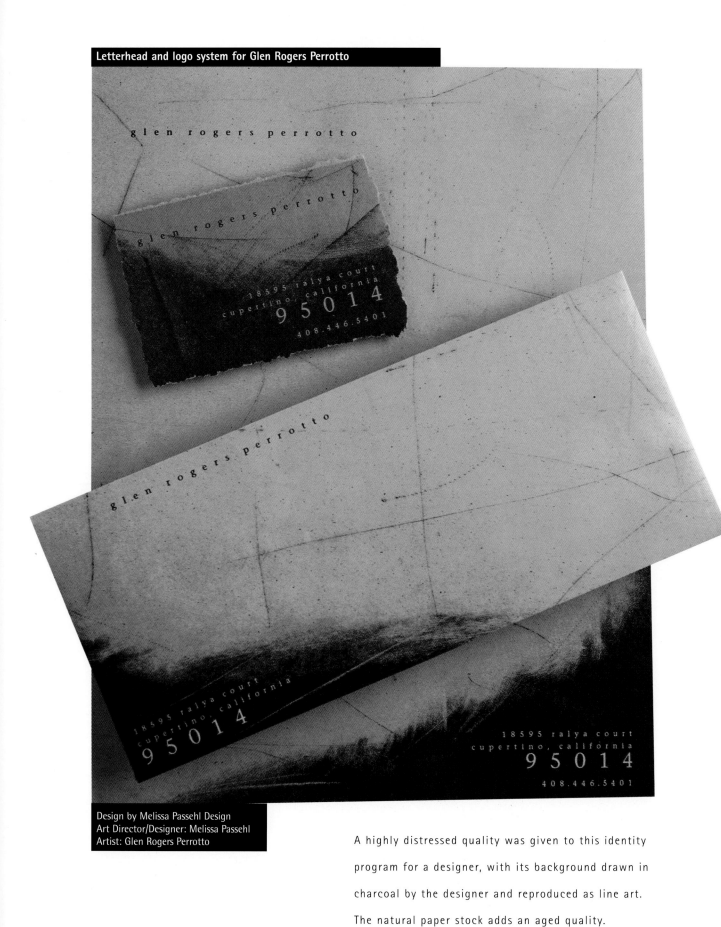

Design by Melissa Passehl Design
Art Director/Designer: Melissa Passehl
Artist: Glen Rogers Perrotto

A highly distressed quality was given to this identity program for a designer, with its background drawn in charcoal by the designer and reproduced as line art. The natural paper stock adds an aged quality.

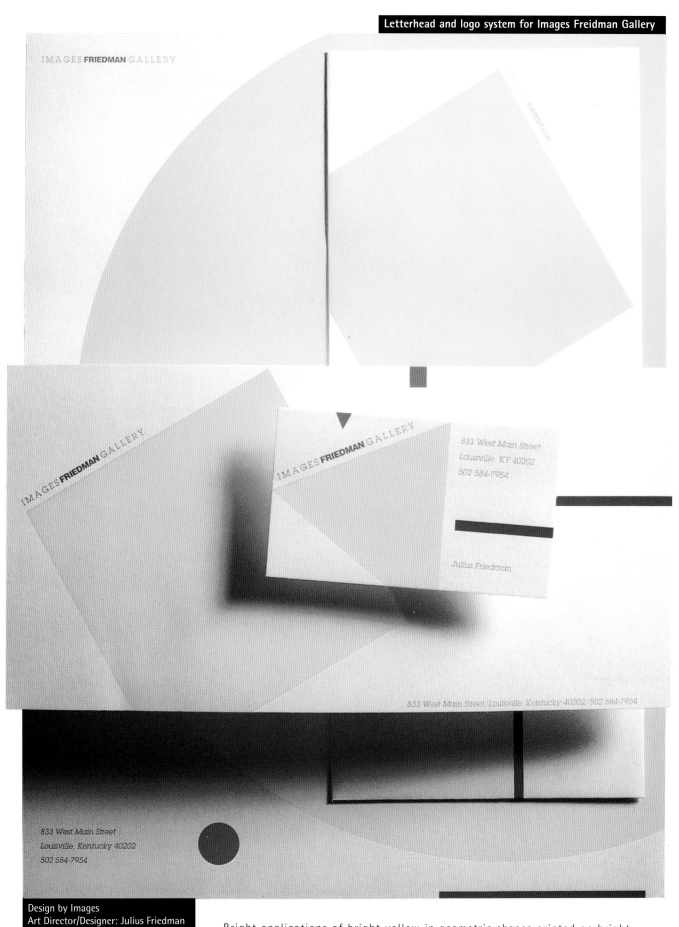

IMAGES **FRIEDMAN** GALLERY

833 West Main Street
Louisville, KY 40202
502 584-7954

Julius Friedman

833 West Main Street/Louisville, Kentucky 40202/502 584-7954

833 West Main Street
Louisville, Kentucky 40202
502 584-7954

**Design by Images
Art Director/Designer: Julius Friedman**

Bright applications of bright yellow in geometric shapes printed on bright white paper are miniature abstract artworks in this stationery for an art gallery. Touches of primary blue and red add to the fun.

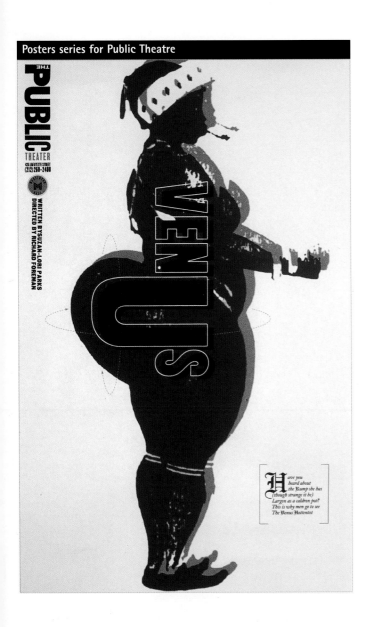

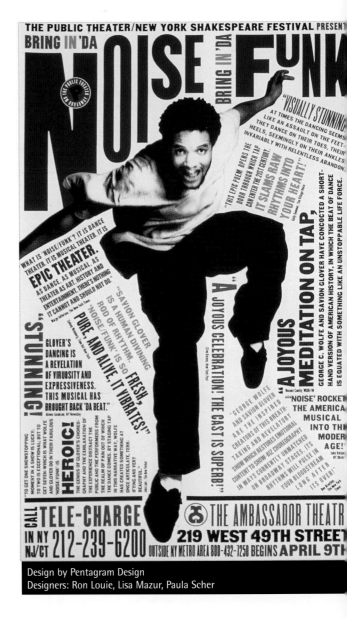

Design by Pentagram Design
Designers: Ron Louie, Lisa Mazur, Paula Scher

Bold, bright colors add to the enthusiastic activity in Pentagram's promotional poster for *Bring in da Noise, Bring in da Funk*. The dark blue figure creates a stark figure against the white background in the *Venus* poster.

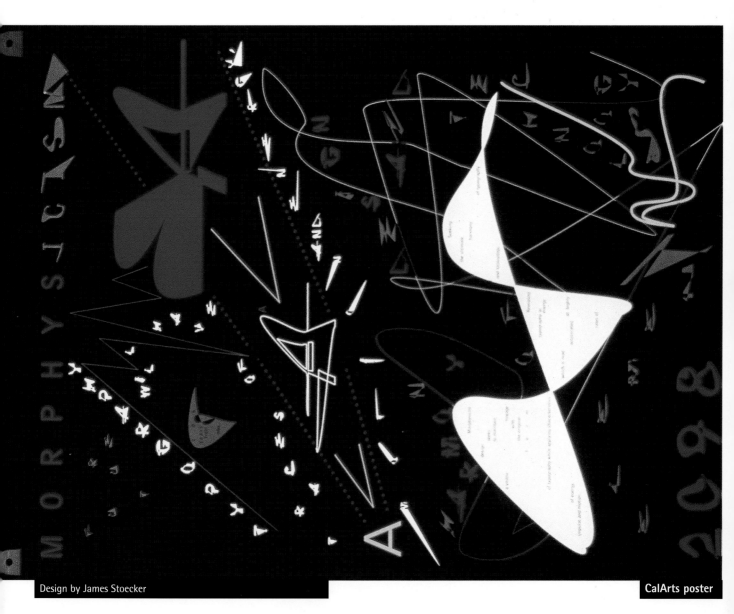

Design by James Stoecker

CalArts poster

The dynamic fluidity of digital type is explored in this poster, which highlights aspects of digital code, outline, and type by separating out elements in electric colors on a black background that suggests neon lights against an evening sky.

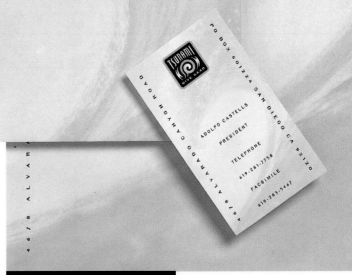

Design by Mires Design, Inc.
Designers: John Ball, Deborah Horn

The letterhead design for a line of scuba-diving gear plays off the tidal-wave product name with an image of a curving wave tinted in a subtle shade of blue that also evokes the sky.

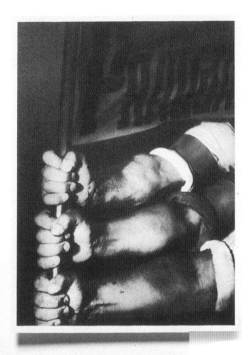

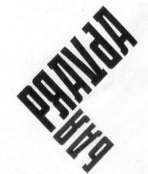

CLOSE COVER ⊙ BEFORE STRIKING

I LAFAYETTE STREET NEW YORK NY 10012 PHONE 212-226-4696

Design by Matteo Bologna Design NY
Designer: Matteo Bologna

The nightclub Pravda unabashedly pays homage to
Russian Constructivism with Cyrillic letterforms and a
bold black-and-red color motif.

RCA Jazz catalog for RCA/BMG

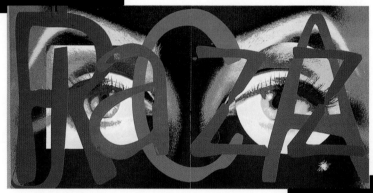

Design by Design Art, Inc.
Designer: Norman Moore

Layered, painterly letterforms in shades of
purple, teal, gold, and russet reverberate
on a catalog cover for RCA jazz records

Design by Pentagram Design
Designer: James K. Brown

The wide stripes of color on the cover of this brochure for BAM's Next Wave Festival suggest t
horizon and the emerging talent showcased by the event. They also help serve as a device to h
organize the various events within the booklet's interior.

The

Brooklyn Academy of Music

1995

Next

Wave

Festival

BAM's 1995 Next Wave
Festival is sponsored by
Philip Morris Companies Inc.

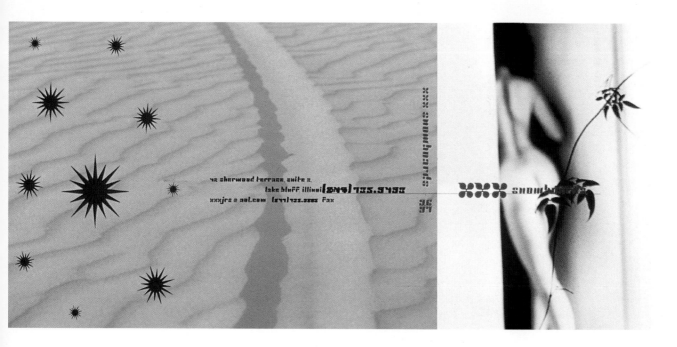

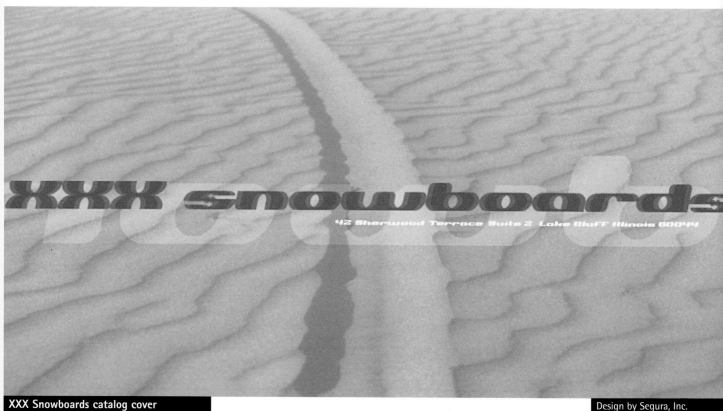

XXX Snowboards catalog cover

Design by Segura, Inc.
Designer: Carlos Segura

A background image tinted in shades of blue adds

a subtle-moody touch to this brochure for XXX

Snowboards and provides contrast to the bright-

red logo.

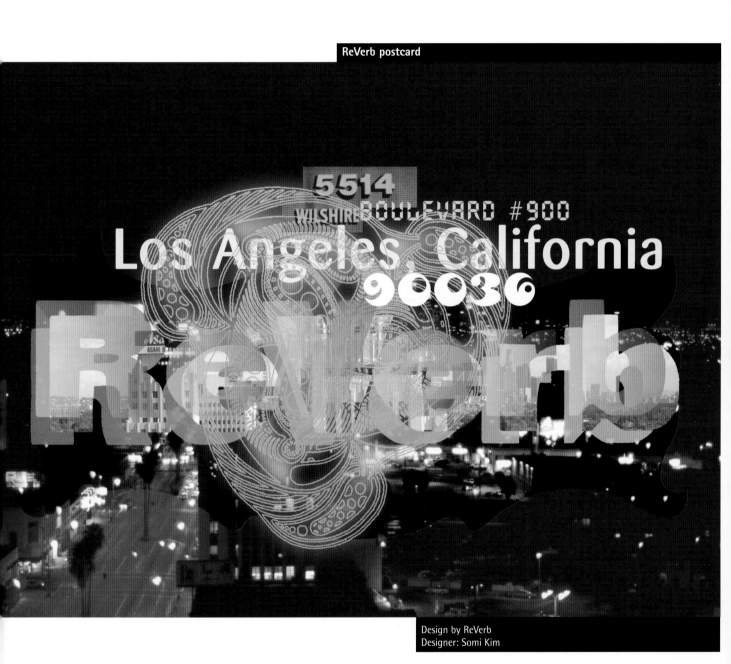

5514
WILSHIRE BOULEVARD #900
Los Angeles California
90036

ReVerb

Design by ReVerb
Designer: Somi Kim

A promotional postcard for ReVerb pulsates with
overlapping letterforms juxtaposed on a photograph of
downtown Los Angeles printed in a palette of seductive
nighttime hues.

The ultramodern typeface Proton by Carlos Segura's T-26 Foundry is presented with the font name set in grey against brightly-colored vertical stripes suggesting, perhaps, the barcode of the future.

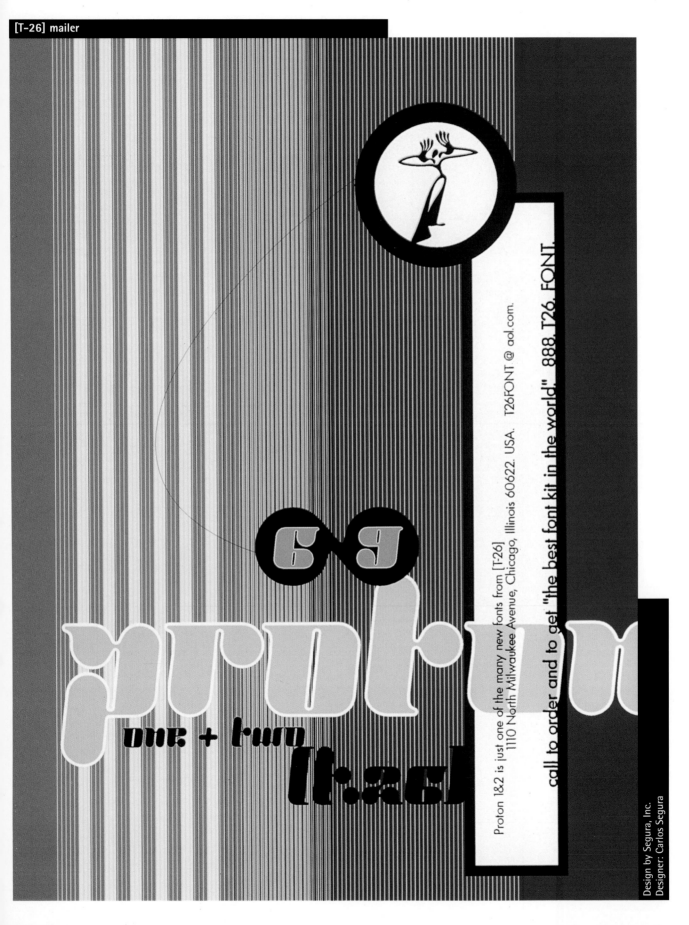

[T-26] mailer

Proton 1&2 is just one of the many new fonts from [T-26] 1110 North Milwaukee Avenue, Chicago, Illinois 60622. USA. T26FONT @ aol.com.

call to order and to get "the best font kit in the world". 888.T26.FONT.

Design by Segura, Inc.
Designer: Carlos Segura

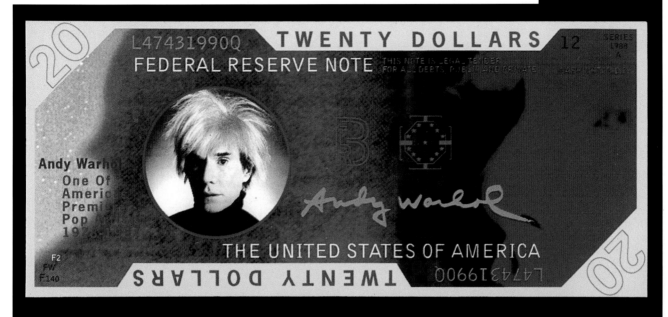

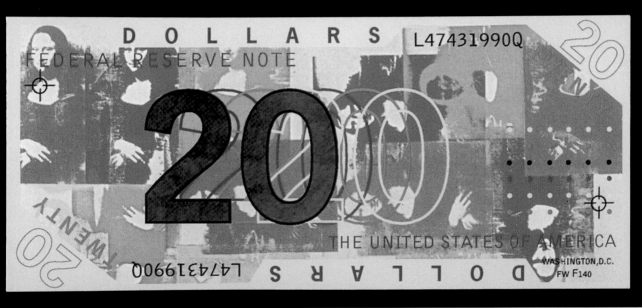

Design by James Stoecker

A promotional piece providing a commentary on
American vernacular design rethinks the staid format
of American currency with Andy Warhol-inspired
imagery silk-screened on the bills in layers of colors.

13th Floor *77*
3309 Pine Avenue
Manhattan Beach, CA 90266

Angelo Sganzerla *56*
Via Crema 27
21035 Milano
Italy

The Dynamic Duo *49*
95 Kings Highway South
Westport, CT 06880

Associates Design *64, 65, 67*
3177 MacArthur Boulevard
Northbrook, IL 60062

Becker Design *81*
225 East Saint Paul Avenue
Suite 300
Milwaukee, WI 53202

Bennett Peji Design *11*
5145 Rebel Road
San Diego, CA 92117

Blue Sky Design *74*
Robert Little
6401 SW 132nd Court Circle
Miami, FL 33183

Brian Cronin *43*
682 Broadway
New York, NY 10012

Campbell Fisher Ditko *72*
3333 East Camelback
Phoenix, AZ 85018

Clifford Selbert Design *82*
2067 Massachusetts Avenue
Cambridge, MA 02140

Concrete *30, 36*
633 S. Plymouth Court
Suite 208
Chicago, IL 60605

David Carter Design *69*
4112 Swiss Avenue
Dallas, TX 75204

Design Art, Inc. *90*
6311 Romaine Street
Los Angeles, CA 90038

Ed Phelps *59*
Two in Design
1163 14th Place NW
Atlanta, GA 30309

Free-Range Chicken Ranch *45*
330A East Campbell Street
Campbell, CA 95008

George Tscherny, Inc. *60*
238 E. 72nd Street
New York, NY 10021

Greteman Group *22*
142 North Mosley
Wichita, KS 67202

Hornall Anderson Design Works
15, 17
1008 Western Avenue
Suite 600
Seattle, WA 98104

Images *85*
1835 Hampden Court
Louisville, KY 40205

Independent Project Press *23, 24*
Box 1033
Sedona, AZ 86339

James Stoecker *87, 95*
740 16th Avenue
Lenlo Park, CA 94025

Kelly O. Stanley Design *83*
3205 North Medford Avenue
Indianapolis, IN 46222

Liska and Associates, Inc. *33*
676 N. St. Clair Suite 1550
Chicago, IL 60611

Love Packaging Group *35*
410 E. 37th Street North
Plant 2 Graphics Department
Wichita, KS 67219

Luis Fitch Company *40*
4104 Pinetree Drive
10th Floor # 1031
Miami Beach, FL 33140

Marcolina Design, Inc. *44*
1100 E. Hector Street
Suite 400
Conshohocken, PA 19428

Matteo Bologna Design NY *89*
142 West 10th Street #2
New York, NY 10014

Melissa Passehl Design *84*
1215 Lincoln Avenue
Suite 7
San Jose, CA 95125

Mike Quon Design Office *26, 52*
53 Spring Street
New York, NY 10012

Mires Design, Inc. *7, 16, 42, 88*
2345 Kettner Boulevard
San Diego, CA 92101

ModernArts Packaging *55, 57*
38 West 39th Street
New York, NY 10018

Moore Moscowitz *31*
99 Chauncy Street
Suite 720
Boston, MA 02111

Muller + Company *41*
4739 Belleview
Kansas City, MO 64112

Nesnadny + Schwartz *28, 29*
10803 Magnolia Drive
Cleveland, OH 44106

New Idea Design, Inc. *47*
3702 S. 16th Street
Omaha, NE 68107

Newell and Sorrell *13*
14 Utopia Village
Chalcot Road
London NW1 8LH
England

Olson and Johnson Design Co. *14*
3107 E. 42nd Street
Minneapolis, MI 55406

Paul Davis Studio *73*
14 East 4th Street
New York, NY 10012

Pentagram Design *86, 91*
204 Fifth Avenue
New York, NY 10010

Peterson & Co. *76*
2200 N. Lamar Suite 310
Dallas, TX 75202

Planet Design Company *27, 32, 39*
305 Williamson Street
Madison, WI 53703

Raven Madd Design Company *68*
P. O. Box 11331 Wellington
Level 3 Harcourts Building
Cnr. Grey St./Lambton Quay
New Zealand

ReVerb *93*
5514 Wilshire Boulevard #900
Los Angeles, CA 94115

Rick Eiber Design *79*
31014 SE 58th Street
Preston, WA 98050

Robin Lipner Digital *71*
220 West 21st Street, 2E
New York, NY 10011

Sackett Design Associates *54*
2103 Scott Street
San Francisco, CA 94115

Sagmeister, Inc. *37*
222 West 14 Street #15 A
New York, NY 10011

Sampson Tyrrell *9*
6 Mercer Street
London,WC2H 9QA
United Kingdom

Sayles Graphic Design *12, 66*
308 Eighth Street
San Francisco, CA 94115

Segura, Inc. *8, 92, 94*
362 West Chestnut Street
First Floor
Chicago, IL 60610

Set Point Paper Co. Inc. *61*
31 Oxford Road
Mansfield, MA 02048

Stoltze Design *34*
49 Melcher Street
Boston, MA 02210

SullivanPerkins *19, 48*
2811 McKinney Avenue
Suite 320 LB111
Dallas, TX 75204

Supon Design Group, Inc. *10*
1000 Connecticut Ave., #415
Washington, DC 20036

Swieter Design *53*
3227 McKinney
Suite 201
Dallas, TX 75204

The Vision Group *78*
26 Archdale Road
Roslindale, MA 02131

Vaughn Wedeen Creative
25, 46, 70, 80
407 Rio Grande NW
Albuquerque, NM 87104

Watt, Roop, & Co. *18*
1100 Superior Ave.
Cleveland, OH 44114

WOW Sight + Sound *50-51*
520 Broadway, Second Floor
New York, NY 10012

Yellow M *20-21*
The Arch, Hawthorne House
Fourth Banks
Newcastle upon Tyne NE1 3SG
England